IMAGES
of America

MAINE'S
COVERED BRIDGES

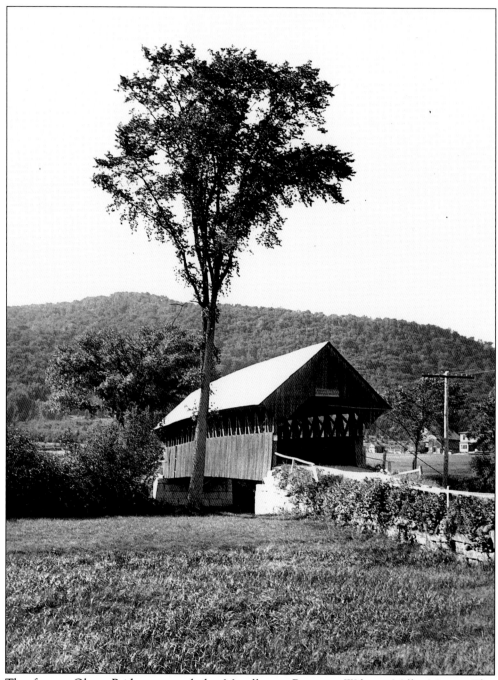
The former Olson Bridge spanned the Magalloway River at Wilsons Mills, Maine. This photograph was taken by Raymond Brainerd on September 7, 1937. The bridge was originally on a dead-end road, which later became part of Route 16. It was very similar in appearance to the existing Bennett Bridge downstream, and photographs of the two bridges are often confused. (NSPCB Archives.)

IMAGES of America
MAINE'S COVERED BRIDGES

Joseph D. Conwill

Copyright © 2003 by Joseph D. Conwill
ISBN 978-0-7385-1271-6

Published by Arcadia Publishing
Charleston, South Carolina

Printed in the United States of America

Library of Congress Catalog Card Number: 2003106970

For all general information contact Arcadia Publishing at:
Telephone 843-853-2070
Fax 843-853-0044
E-mail sales@arcadiapublishing.com
For customer service and orders:
Toll-Free 1-888-313-2665

Visit us on the Internet at www.arcadiapublishing.com

Contents

Acknowledgments 6

Introduction 7

1. Androscoggin County 9
2. Aroostook County 17
3. Cumberland and York Counties 29
4. Franklin County 41
5. Kennebec County 49
6. Lincoln and Washington Counties 57
7. Oxford County 65
8. Penobscot County 93
9. Piscataquis County 111
10. Somerset County 119

ACKNOWLEDGMENTS

Philip M. Wentzel of the Maine Department of Transportation (Maine DOT) has been a great help in locating photographs and documentary sources. Without his assistance, this book would never have come about. To him I owe special thanks, and also to Everett Barnard, P.E. The staff people at the Maine Historical Society in Portland and the Maine State Library in Augusta have been very helpful, as has been my colleague David W. Wright of the National Society for the Preservation of Covered Bridges (NSPCB). I would also like to thank Kirk F. Mohney of the Maine Historic Preservation Commission and Wayne Perry.

It would be impossible to describe all the encouragement that historian Richard Sanders Allen has given me for more than 30 years, and this book is dedicated to him.

INTRODUCTION

Covered bridges have been part of the American landscape for two centuries now. Maine once had more than 150 of them, of which seven remain today. There have also been two covered bridges recently built to replace old ones that had been accidentally destroyed, bringing the current state total to nine.

Why were bridges covered? They were covered simply to protect the timber trusswork from decay. If you take the roof and side boards off a covered bridge, you will see a massive framework on the sides and overhead, which carries all the load to the abutments, or piers. In fact, from a distance, it would look rather like a steel truss bridge. However, since the structural members are wood, they will decay unless protected from the weather. Thus, the roof and siding are necessary.

Central Europe has had covered bridges since at least the 1500s, and the idea was being discussed in America by the late 1700s. So far as is known, however, the first covered bridge was not built on our side of the ocean until 1805, in Philadelphia. The idea soon spread to Maine, where a covered bridge was completed over the Kennebec River at Augusta in 1818.

Early bridges used a variety of framing styles, but each part of the state developed a preference for a particular truss plan. Down east and in Aroostook County, the Long truss was the usual standard. Patented by Stephen H. Long in 1830, it consisted of a series of boxed Xs that could be prestressed by a sophisticated series of wedges to resist deflection under load. Early Long trusses on the Military Road to Houlton provided a prototype for this area's builders. In western Maine, the influence of famed bridge wright Peter Paddleford caused his truss to become the standard there. Paddleford was from Littleton, New Hampshire, and was active in Fryeburg, Maine, in the 1840s. His design used a distinctive elongated countertie, which helped to spread the load over a larger area of the trusswork. The Town lattice design, so widely used elsewhere in New England, was early popularized through the work of Isaac Damon of Northampton, Massachusetts. It gained a spotty acceptance but, in western Maine, was largely superseded by the Paddleford truss, and there are no Town lattice bridges left in the state. The Howe truss was a series of boxed Xs like the Long truss, but with vertical iron rods instead of wooden posts. It was used on railroads and occasionally for highway bridges, especially in the Bangor area. The simple or rafter trusses, kingpost and queenpost, were widely used for open timber bridges and were occasionally covered as well.

There is not space here to describe the complicated history of these various truss types, but even the casual observer will note the major differences. The best history of the subject is the set of books by Richard Sanders Allen, published by Stephen Greene Press from 1957 to 1970. They are now out of print, but *Covered Bridges of the Northeast* should be available in most New England libraries.

The existing Robyville Bridge in Corinth is a good example of the Long truss. Oxford County has five Paddleford trusses, and the Sunday River Bridge in Newry is an especially fine example. In fact, it was one of several covered bridges nationwide selected recently for special study by the Historic American Engineering Record in Washington, D.C. The Watson Settlement Bridge in Littleton is a Howe truss, but although it is an attractive structure, its truss is not

typical of the type because of variant regional influence from New Brunswick building traditions. Babb's Bridge, between Gorham and Windham, is our only queenpost covered bridge.

The future of covered bridges in Maine seems fairly secure. Other states have more of them, but some regions have recently embarked on "improvement" programs that are modifying covered bridges so much that there is little historic fabric left. Indeed, several in Vermont and elsewhere have been torn down and completely replaced with all-new covered bridges. Whatever this may be, it is not historic preservation. In Maine, however, there has been a legislative mandate since the late 1950s to preserve the remaining covered bridges, and the engineers in charge of their maintenance, such as Roy Wentzel and Everett Barnard, have had a genuine interest in history.

The appeal of covered bridges remains hard to define, even for people who have seen large numbers of them. The 19th-century rural landscape remained intact in much of Maine well into the 1960s. Those of us old enough to have marveled at its loveliness will find in covered bridges some reminder of what has been lost to the suburbanization that has reached every part of the state by now. However, even younger people who have no memory of the old landscape find covered bridges attractive.

The chapters in this book are arranged alphabetically by county. Where two counties are combined in one chapter, they are listed with the name that occurs first in order. The short introductory text tells of significant bridges in the county for which no good photographs could be found. We have included a few views of noncovered bridges that are historically related, especially of boxed pony trusses. These are timber truss bridges of short span that have no lateral bracing overhead and have the sides boarded in separately, with no roof. Some earlier historians, influenced by the evolutionary thinking then much in vogue, thought that boxed pony trusses were precursors to fully covered bridges. This is erroneous, and instead they were a later development, but they are interesting structures, and we have none left in Maine.

The historical record is never complete. Please send any corrections or additions to Joseph D. Conwill, P.O. Box 829, Rangeley, Maine, 04970.

One
ANDROSCOGGIN COUNTY

At town meeting in 1812, Turner voted to build a new bridge over the Twenty Mile Stream (now the Nezinscot River), provided that certain individuals would cover it. This may mean that Turner had the first covered bridge in Maine, but probably not. Before c. 1825, "to cover" a bridge commonly meant to install the finished deck surface on an open bridge.

Turner was, however, the scene of some early bridges over the Androscoggin River, involving competition among truss types. North Turner Bridge (to Leeds) was an 1828 Town lattice truss, lost to an ice freshet in 1839 and built anew. Timbers from the former bridge were used to brace a nearby barn, which is still standing (though just barely). Downstream, Turner Center Bridge (to Greene) was a Long truss built in 1834 and was also lost to the 1839 freshet.

Great Falls, between Lewiston and Auburn, was once the site of a deck truss covered railroad bridge, meaning that it was fully boarded, but the trains ran on top. The highway bridge downstream was briefly covered and was later a boxed pony truss. Auburn also had a covered bridge on Main Street near Barker Mill, and Lewiston had a covered overpass on Bridge Street over railroad tracks. Mechanic Falls had a McCallum deck truss covered bridge on the Grand Trunk Railway.

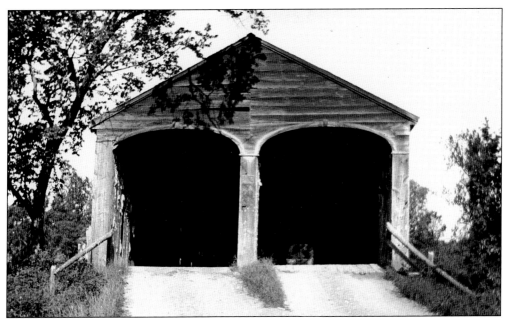

This is the 1839 North Turner Toll Bridge, built to replace the 1828 bridge lost to a freshet. Like the previous bridge, it was a Town lattice truss, and it was a "double-barrel" bridge. It had two lanes for traffic, separated by a center truss. (Maine DOT files.)

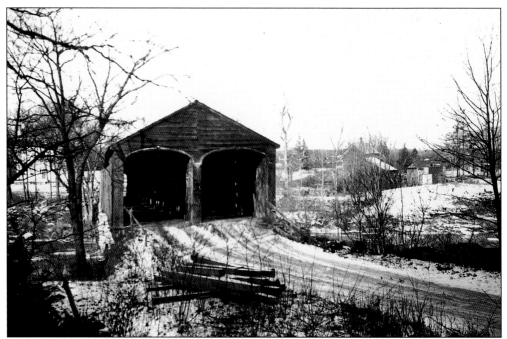

North Turner Toll Bridge was on the Turner-Leeds town line, crossing to an island in the Androscoggin River. This view, from the island in Leeds, looks west toward Turner. (Maine DOT files.)

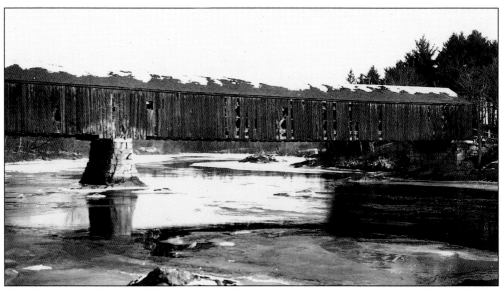

As seen in this side view, North Turner Toll Bridge was a two-span structure. It served as a toll bridge until 1924. The views on pages 9 through 13 all date from the 1934–1935 period. (Maine DOT files.)

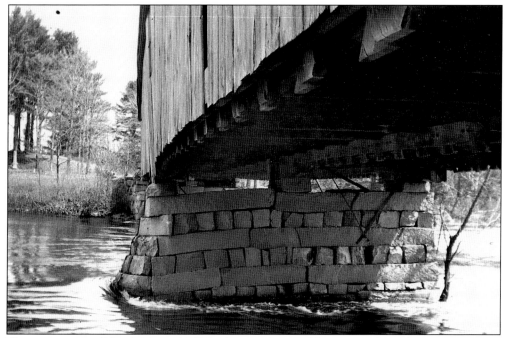

The center pier of North Turner Toll Bridge was damaged by erosion from the strong currents in the Androscoggin River. The upstream end settled, causing the bridge trusses to sag. (Maine DOT files.)

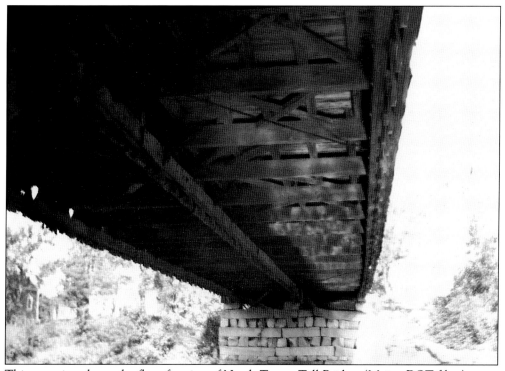

This rare view shows the floor framing of North Turner Toll Bridge. (Maine DOT files.)

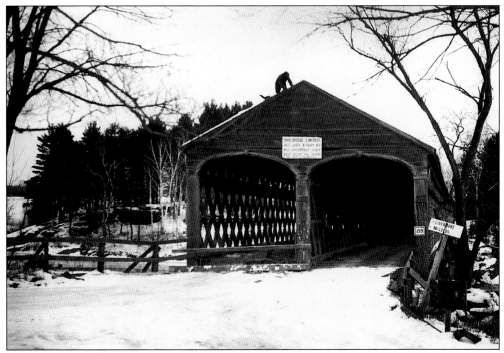

This photograph shows demolition beginning at North Turner Toll Bridge on December 13, 1935, and only one lane open. The view is from Turner, looking toward Leeds. Note the sign for Route 219 on the bridge portal. (Maine DOT files.)

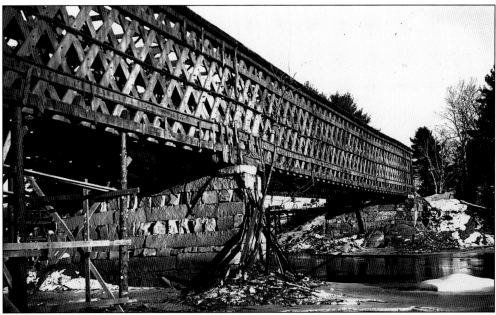

Eleven days later, demolition is much further along. The Town lattice trusswork is clearly revealed. (Maine DOT files.)

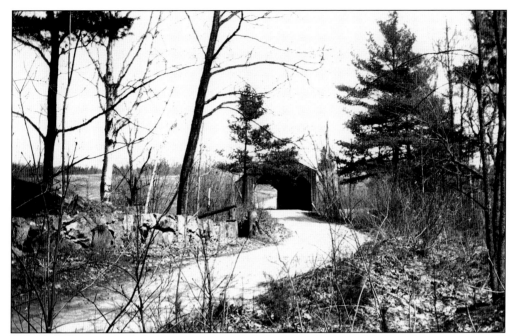

The North Turner Toll Bridge crossing included a second covered bridge that is not as well known. It was over the smaller east channel of the Androscoggin River from the island back to the mainland, entirely in Leeds. It had a 19-foot roadway, wide enough for two lanes of traffic, but without a center truss. (Maine DOT files.)

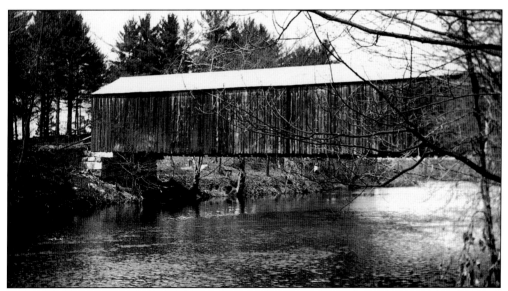

Here is another view of the separate east channel crossing at North Turner Toll Bridge. So far as is known, this bridge was built at the same time as the better-known west channel bridge. (Maine DOT files.)

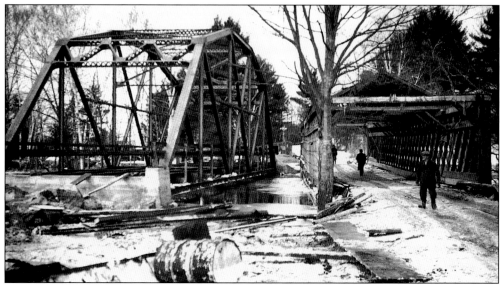

The east channel crossing at North Turner Toll Bridge went out in the 1936 flood shortly after this photograph was taken, but it was already being torn down anyway. Afterward, the replacement steel bridges were raised three feet. (Maine DOT files.)

Livermore Falls was at first entirely in the town of Livermore. In 1843, the land on the east side of the river was set off as the separate town of East Livermore (later called Livermore Falls). Here is the covered bridge over the mighty Androscoggin River. (Richard Sanders Allen Collection, NSPCB Archives.)

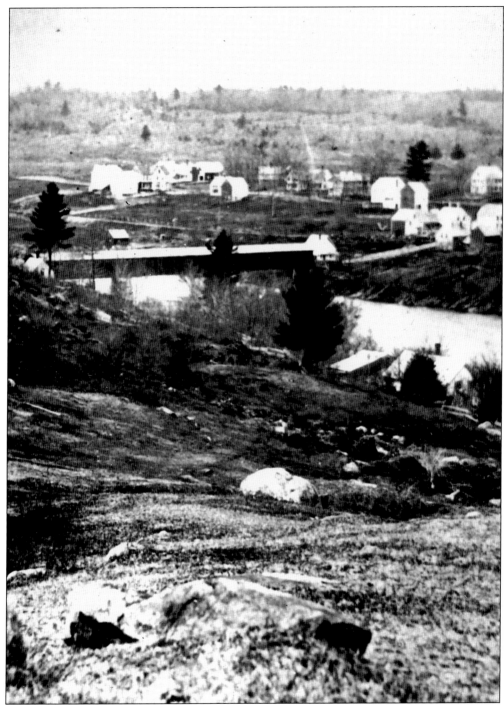

This is another view of Livermore Falls. The first bridge was built in 1858 and was a noncovered Haupt truss. The Haupt plan, patented in 1839, was used occasionally in Maine, but we do not know the name of the builder who first brought it here. After the first bridge was lost to a freshet, it was replaced in 1872 with this covered bridge, which was also a Haupt truss. It lasted until the famous flood of 1896. (Richard Sanders Allen Collection, NSPCB Archives.)

This old view of the Great Falls between Auburn and Lewiston shows the deck truss railroad bridge over the Androscoggin River. (Richard Sanders Allen Collection, NSPCB Archives.)

Two

Aroostook County

Much of Aroostook County, which covers an area larger than several states, was disputed territory with Canada until the border was finally defined in the Webster-Ashburton Treaty of 1842. The U.S. Army completed the Military Road from Bangor to Houlton in 1832, involving several sizable bridges on the Long truss plan, patented just two years earlier. The inventor was Lt. Col. Stephen Harriman Long, himself an army man, with the Topographical Engineers. These bridges at prominent locations on the Military Road no doubt furnished an example to other builders, and they help explain why the Long truss was so popular in eastern and northeastern Maine. The most impressive was at Mattawamkeag, but that is over the line in Penobscot County and will be described later.

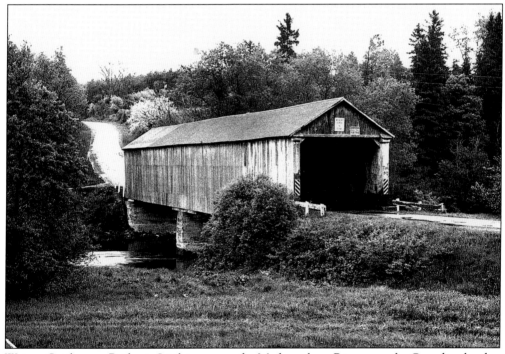

Watson Settlement Bridge in Littleton, over the Meduxnekeag River near the Canadian border, was bypassed in 1984 but still exists. This 1983 view shows the bridge still in service. The original construction date is uncertain, but the best guess is 1903 (not 1911, as is commonly given). It is a Howe truss but shows variant influence from New Brunswick building styles. The custom of referring to a dispersed rural hamlet as a "settlement" is also a regional style often found on the other side of the border.

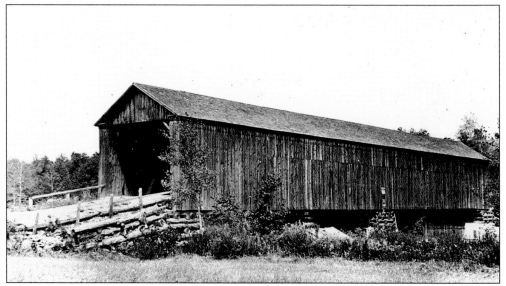

This 1924 view of Watson Settlement Bridge shows that the bridge originally had wood crib abutments and pier. Such foundations are also often found in New Brunswick and Quebec. (Maine DOT files.)

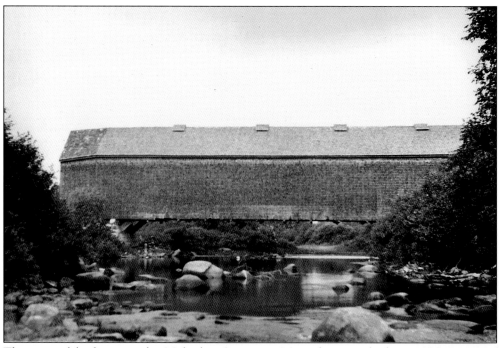

The covered bridge over the Molunkus Stream at Macwahoc was built c. 1876. It was of unknown type, but laminated arches were added to the trusses in 1902. The all-shingled housing style was used on several other Maine bridges and is a regional trademark, but no one has been able to explain the unique trap doors at the roof ridge. Replacement came in 1932. (Maine DOT files.)

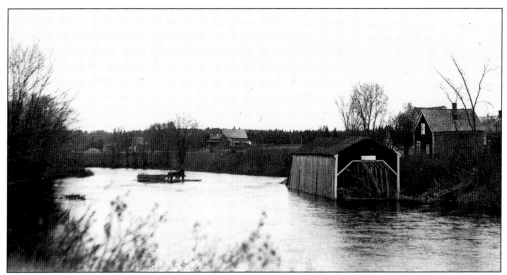
Little is known of this former covered bridge at Haynesville, lost to a flood in 1923. Note the temporary ferry in service in the background. The bridge was a Long truss with laminated arches that were probably added later and was said to have been built in 1867. (Maine DOT files.)

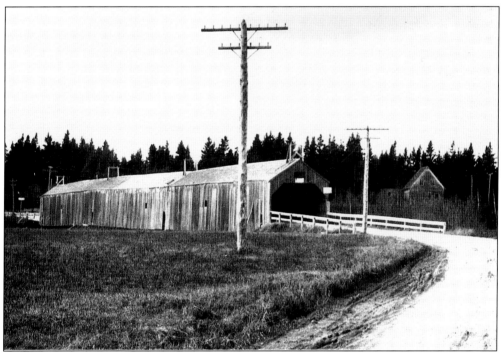
Aroostook River Bridge at Ashland was a three-span covered bridge just over 300 feet long. Of uncertain construction date, it was replaced in 1928. (Maine DOT files.)

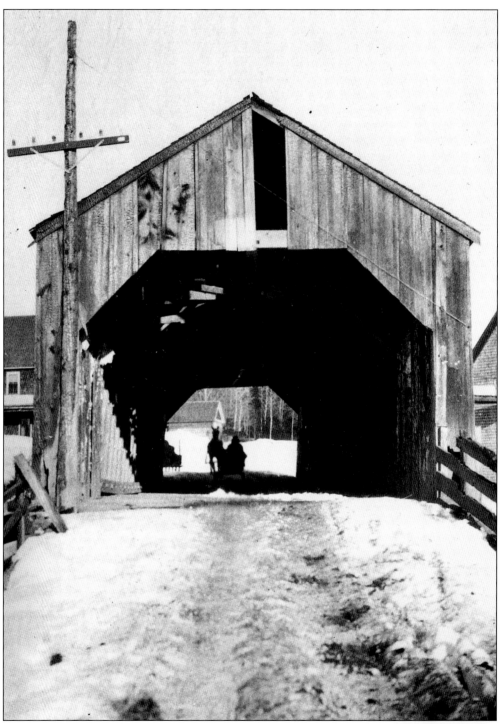
Also in Ashland was this Town lattice truss at Moore's Mill, where there was a small electric power station. It crossed the Machias River, or Big Machias River, not to be confused with the better-known river of the same name in Washington County. It was replaced in 1919. (Maine DOT files.)

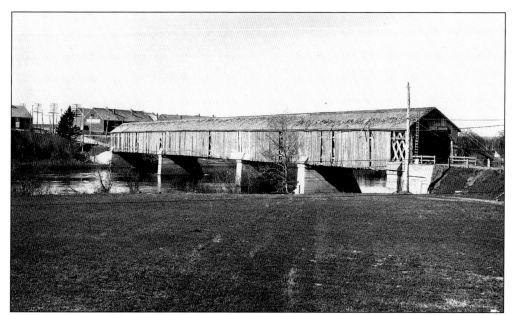

The impressive Caribou Crossing Bridge spanned the Aroostook River about a mile and a half north of downtown Presque Isle. Photographs of it are commonly mixed up, because a prominent postcard publisher once circulated views of this bridge misidentified as the Grimes Mill Bridge in Caribou. This photograph dates from 1932. (Maine DOT files.)

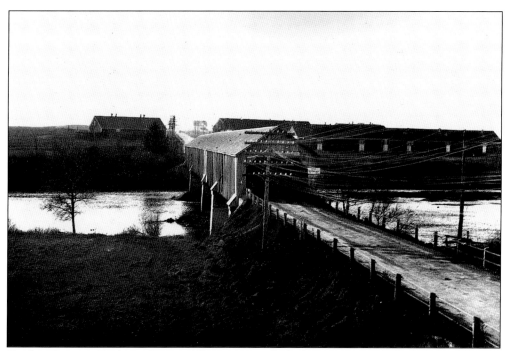

Caribou Crossing Bridge in Presque Isle was originally built in 1858. It was destroyed by a freshet in 1885 and was rebuilt the same year. It was about 425 feet long in three spans, but an extra pier was added in 1929, making it a four-span bridge. The long buildings in the background are potato barns. (Maine DOT files.)

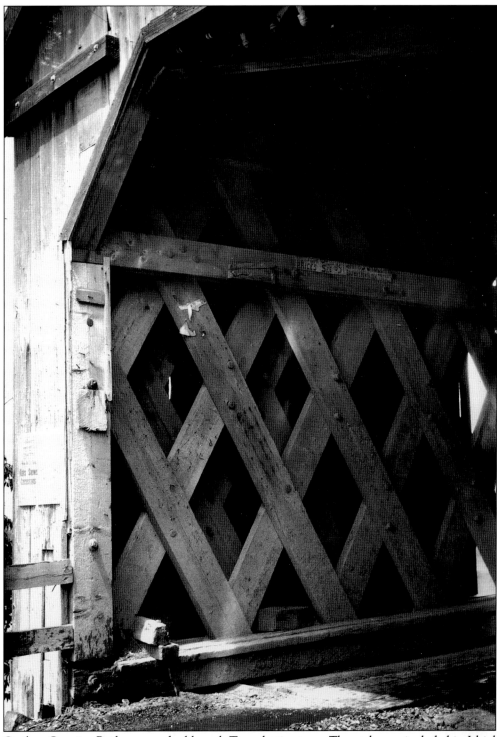

Caribou Crossing Bridge was a double-web Town lattice truss. The style was included in Ithiel Town's second patent (in 1835) but was mainly used for railroad bridges, and highway examples were always rare. (Maine DOT files.)

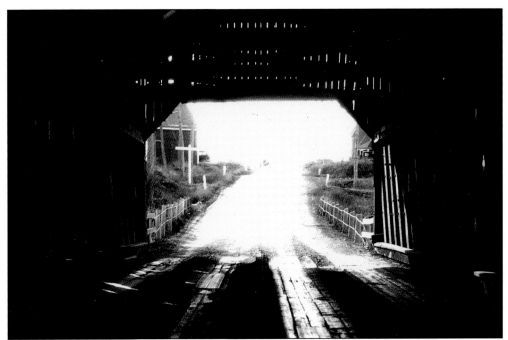

This 1930 view out the portal of Caribou Crossing Bridge in Presque Isle shows that it was a two-lane bridge but not a double barrel; that is, there was no third set of trusses down the middle. This probably explains why the double-web version of the Town lattice truss was used. (Maine DOT files.)

Route 1 approaching Caribou Crossing Bridge was still a gravel highway in 1930. (Maine DOT files.)

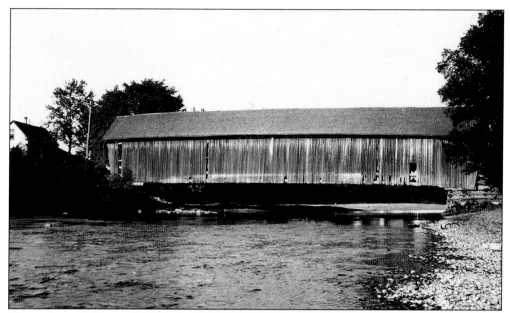
This is the real Grimes Mill Bridge, over the Little Madawaska River in Caribou, in 1924. A prominent postcard publisher confused this bridge with Caribou Crossing in Presque Isle. Grimes Mill Bridge was a Town lattice truss. Note the wood crib abutments. (Maine DOT files.)

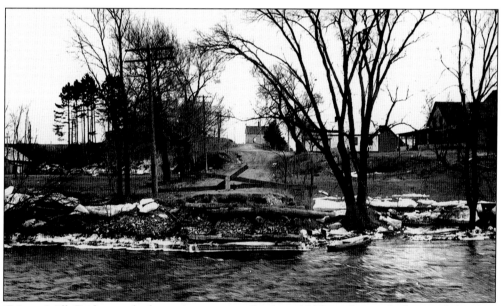
Grimes Mill Bridge washed out in a spring flood in 1928, and very little was left of it. (Maine DOT files.)

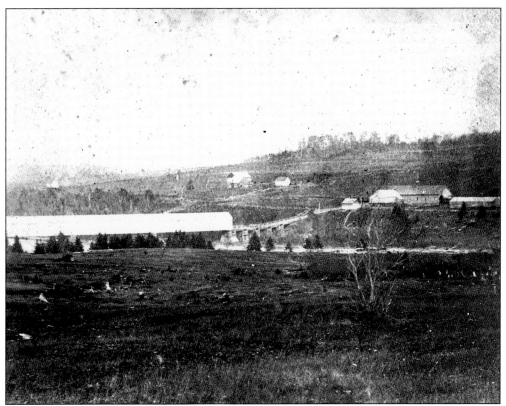

This interesting old view has not been positively identified. It is thought to show the former covered bridge at downtown Caribou over the Aroostook River, built in the early 1860s and destroyed by fire in 1891. (Maine Historic Preservation Commission.)

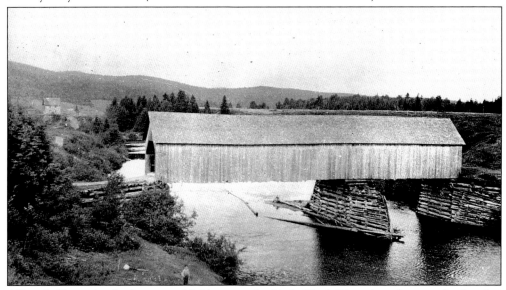

Allagash Plantation had a covered bridge over the Little Black River, but photographs showing it in good condition are rare. Note the wood crib abutments and pier, so characteristic of the north country. (Richard Sanders Allen Collection, NSPCB Archives.)

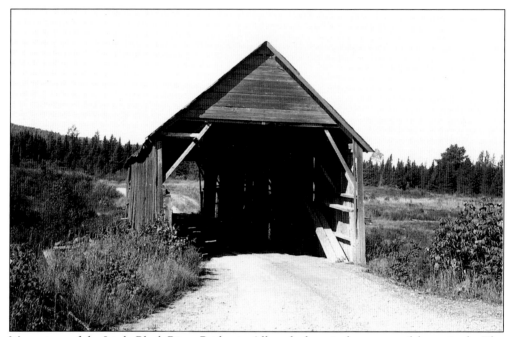
Most views of the Little Black River Bridge in Allagash show its later state of decrepitude. The photograph was taken by Roy A. Wentzel in 1952. (Maine DOT files.)

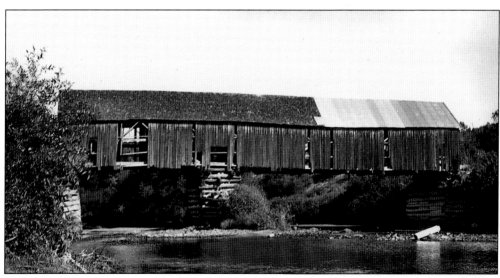
This 1952 Wentzel photograph shows the downstream side of the Little Black River Bridge. (Maine DOT files.)

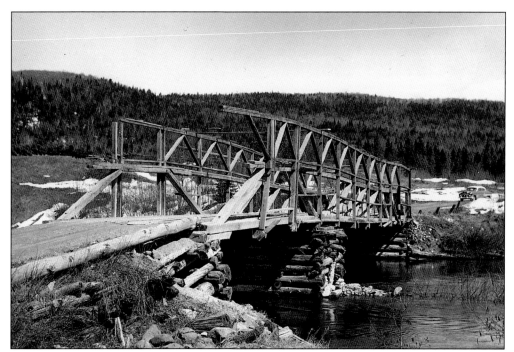

The Little Black River Bridge was demolished in 1955. The framing for the side boarding and roof seems to have been a later addition to the trusswork, suggesting that this was originally an open bridge or perhaps a boxed pony truss. This photograph was taken by Charles A. Whitten. (Maine DOT files.)

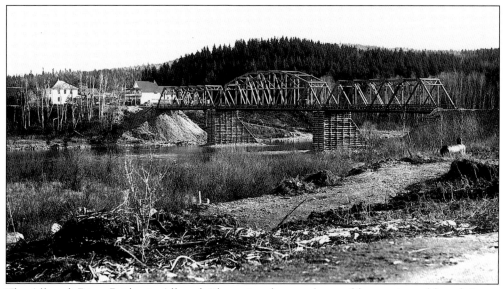

The Allagash River Bridge in Allagash Plantation deserves honorable mention, although it was never covered. It was built as a timber truss in 1944 because of the wartime steel shortage, but it lasted only 11 years. (Maine DOT files.)

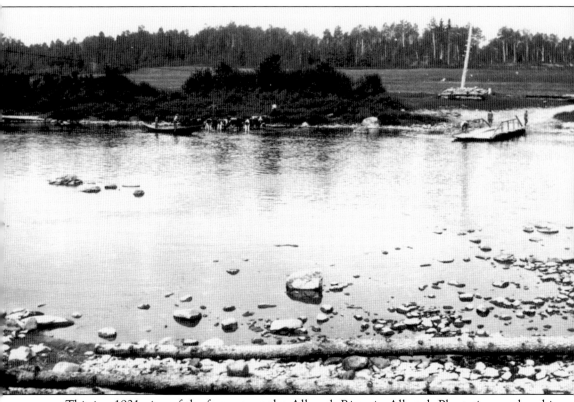

This is a 1921 view of the ferry across the Allagash River in Allagash Plantation, replaced in 1944 by the timber truss in the previous photograph. (Maine DOT files.)

Three

CUMBERLAND AND YORK COUNTIES

Southern Maine had some very early covered bridges, but most of them also disappeared early, and their history is spottily recorded. In Cumberland County, Deering's Bridge over part of Back Cove in what is now Portland is said to have been covered, but the site has been so altered that it is impossible to find. Pride's Bridge between Portland and Westbrook is thought to have been covered, but again there is no good record. Falmouth had several covered bridges, including an early 1837 Town lattice truss at Staples Point, which burned down in 1893. The Grand Trunk Railway had a through McCallum truss bridge at Yarmouth that was probably covered.

York County had covered bridges between Biddeford and Saco over the various channels of the Saco River, and most of the county's other crossings of the Saco were once covered also. The complicated history of early railroads in York County very likely involved some covered bridges, but this history is little known.

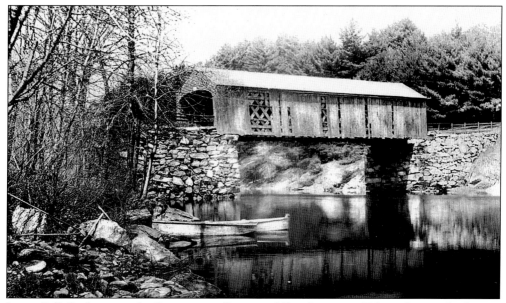

Lower Falls Bridge, over the Presumpscot River on Allen Avenue in Falmouth, was also known as Smelt Hill Bridge. Built in 1845, it was replaced in 1913 by a concrete arch on a much higher level. Remains of the covered bridge abutments still exist. The site may be seen briefly from a distance by travelers on Interstate 295. (Richard Sanders Allen Collection, NSPCB Archives.)

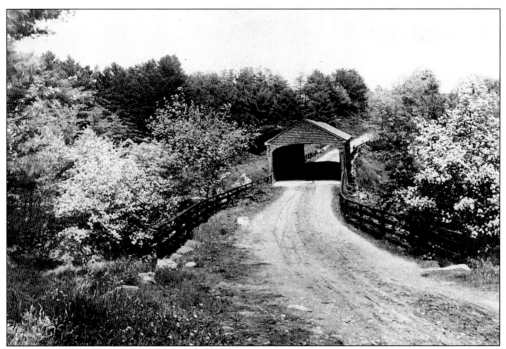

This view of Lower Falls Bridge in Falmouth has been widely circulated, but it is usually misidentified as Oxford, Fryeburg, or some other place. (Richard Sanders Allen Collection, NSPCB Archives.)

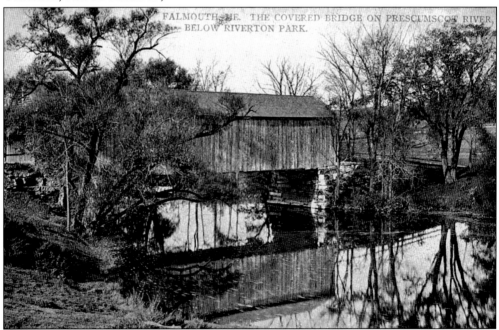

Another covered crossing of the Presumpscot River in Falmouth was Lambert Street Bridge, on what is now Blackstrap Road. It burned down in 1915. This old postcard says it was "below Riverton Park," a popular trolley car destination upstream in Portland. The bridge site is visible from the Maine Turnpike. (Richard Sanders Allen Collection, NSPCB Archives.)

For several years in the 1860s and 1870s, there was a covered bridge over the Presumpscot River at Cumberland Mills in Westbrook. The large factory to the left made tin cans. The right side of the road is now occupied by the S.D. Warren paper mill. (Richard Sanders Allen Collection, NSPCB Archives.)

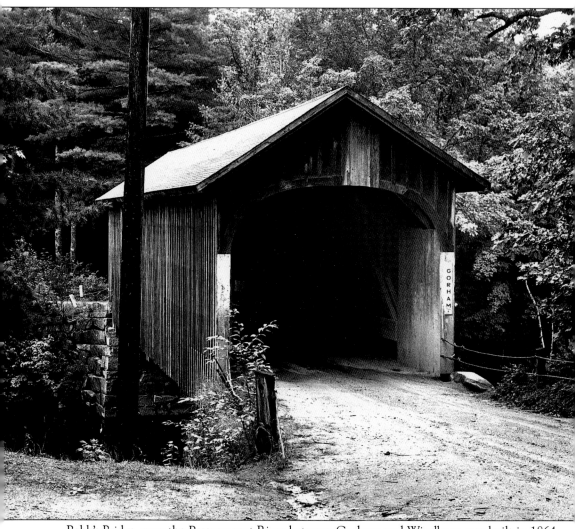

Babb's Bridge, over the Presumpscot River between Gorham and Windham, was built in 1864, and this photograph was taken in 1958. It was a queenpost truss, elaborated with extra framing because of its 66-foot clear span. On May 6, 1973, it was destroyed by a fire of suspicious origin, but local officials wanted it back. Engineer Everett Barnard carefully drew up replacement plans, and a department of transportation crew did the framing. The new bridge opened in 1976 and is an exact copy of the old. (Herbert Richter Collection, NSPCB Archives.)

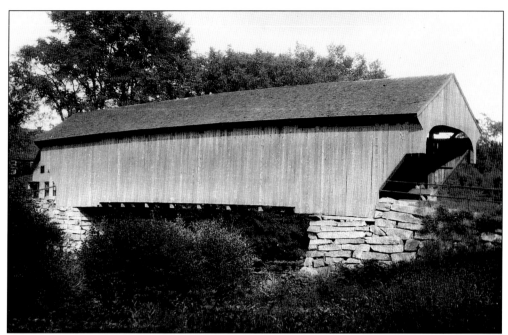
Edes Falls Bridge crossed the Crooked River in Naples, north of Sebago Lake. It was a Paddleford truss and was lost to the 1936 flood. (Maine DOT files.)

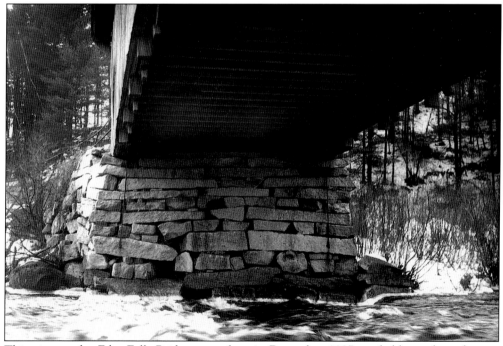
This view under Edes Falls Bridge was taken in December 1927, probably to show damage from the famous flood that year. Note the old iron rods tying the bridge to the abutments. (Maine DOT files.)

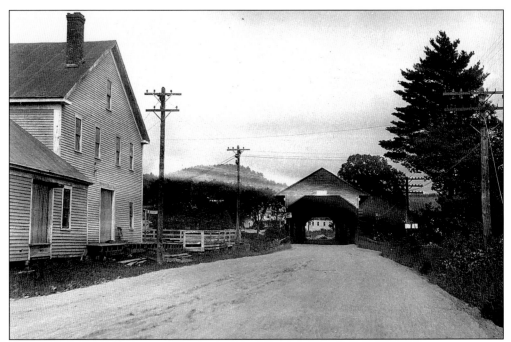

Depot Bridge crossed the Saco River between Cornish (York County) and Baldwin (Cumberland County). It was originally built in 1874 to reach Cornish Station, because the railroad came through on the Baldwin side of the river. It washed out and was replaced with a new covered bridge in 1898. The large building to the left was a corn cannery. (Maine DOT files.)

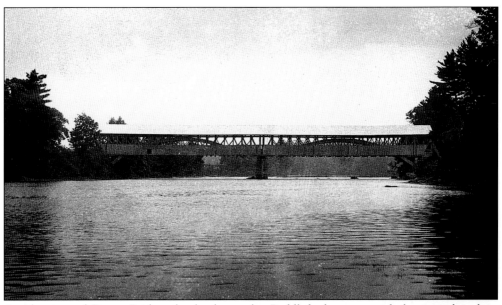

A side view of Depot Bridge clearly shows the Paddleford trusses with laminated arches. (Maine DOT files.)

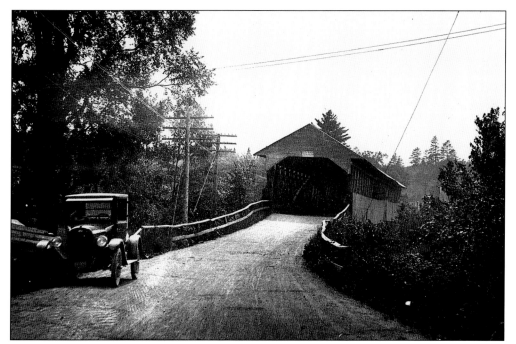
This photograph of Depot Bridge, from Cornish to Baldwin, was taken on July 22, 1924, as were the views on page 34. The car probably belonged to the state engineer who was inspecting the bridge. (Maine DOT files.)

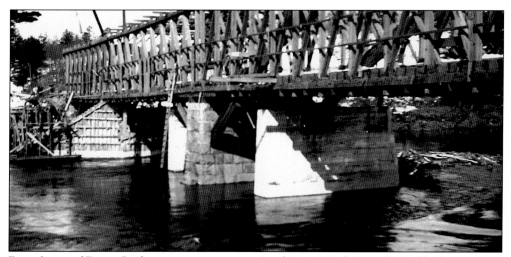
Demolition of Depot Bridge was in progress on April 24, 1928. (Maine DOT files.)

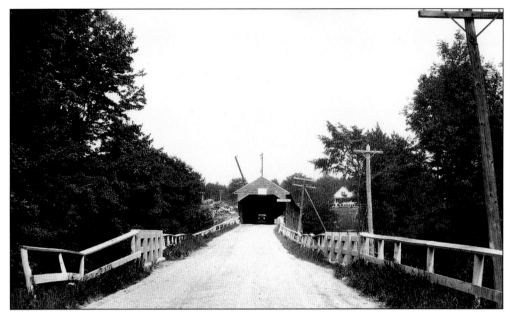

East Limington Bridge crossed the Saco River to Standish, also on the York-Cumberland county line. It was a three-span Paddleford truss, built by Jacob and Horace Berry of Conway, New Hampshire, in 1884. (Maine DOT files.)

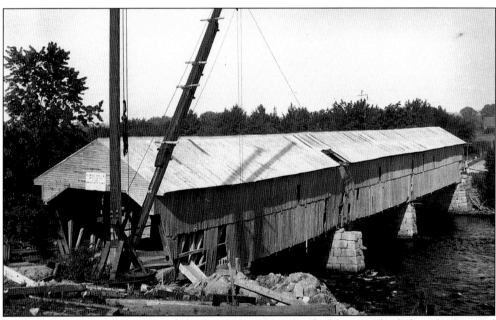

East Limington Bridge was demolished in 1929. Note the double tier of side boards. Covered bridges had to be "snowed" in winter; that is, someone had to be paid to put snow inside to permit the passage of sleighs. This bridge was originally boarded only halfway up in the hope that it would snow itself, but the experiment did not work and the bridge was later fully boarded. (Maine DOT files.)

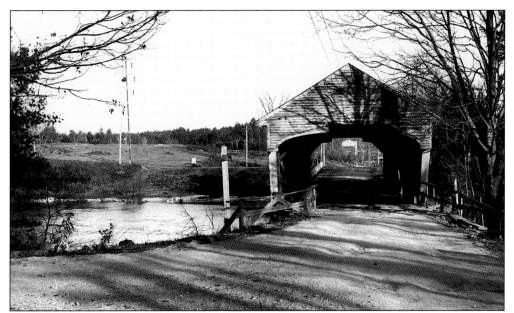

Bonny Eagle Bridge was over the Saco River, Hollis–Standish, also on the York-Cumberland county line. The site was prone to flood damage; note the erosion that is fenced off just to the left of the bridge portal. The bridge was a Paddleford truss dating from the 1880s, and laminated arches were added c. 1927. Replacement came in 1938–1939. (Maine DOT files.)

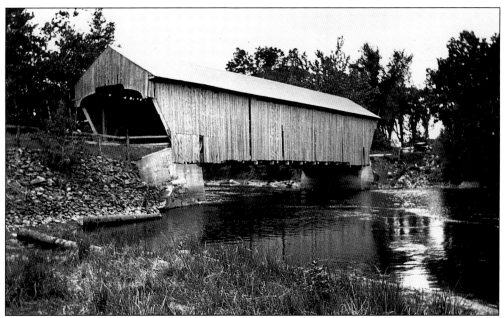

This 1931 view of the other end of Bonny Eagle Bridge shows that repair work had been done to this portal. Very old views refer to the area as the Saco River Gorge, but the site was altered in 1911 by construction of a hydroelectric project. At that time, the bridge was raised; note the concrete abutments. (Maine DOT files.)

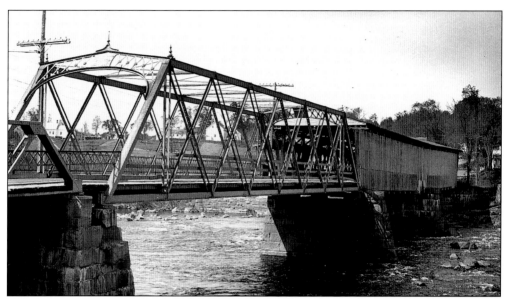

The Saco River is entirely in York County at West Buxton. The site was once known as Moderation Village, and the bridge crossed to Hollis. This unorthodox-looking structure was built c. 1850 as a fully covered Paddleford truss, but part of it was lost to the 1896 flood and replaced with an iron span in 1898. You can just barely make out a separate sidewalk on the far side. The entire structure was lost to the 1936 flood. (Maine DOT files.)

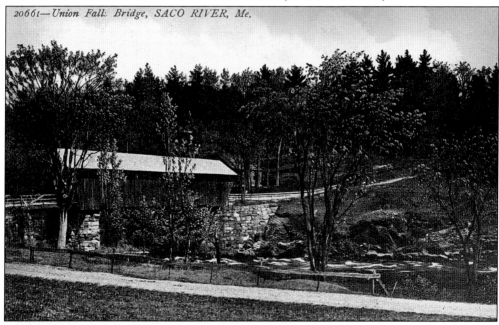

Union Falls Bridge crossed the Saco River between Buxton and Dayton. It was replaced in 1917 by a steel truss some distance downstream, because a new power dam was going to inundate the site. The covered bridge remained standing during construction of the dam and was then blown up in 1921 as a stunt for a James Oliver Curwood movie filmed in the area. The steel truss was lost to the 1936 flood, and there is no bridge here now. (Richard Sanders Allen Collection, NSPCB Archives.)

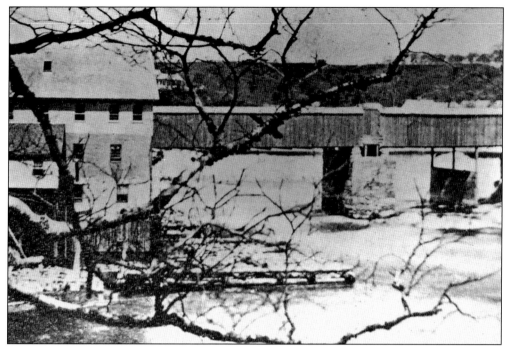

Southern Maine had a number of boxed pony trusses, in which the sides were completely boarded in separately, with no roof. This unusually lengthy example crossed the Androscoggin River from *Maine* Street in Brunswick to Old *Main* Street in Topsham. It was built after a short-lived covered bridge was lost to fire in 1842, and it lasted until 1877. (Richard Sanders Allen Collection, NSPCB Archives.)

The Boston and Maine Railroad had numerous boxed pony overpasses. This example in Arundel just northeast of Kennebunk lasted into the 1990s.

Maine's very last boxed pony truss was Hobbs Bridge in Berwick. Originally square-ended like the Arundel structure, it was later rebuilt in a different style. When it was removed in 1999, the timbers were salvaged for rebuilding elsewhere, but hopes of this are now fading.

Four

FRANKLIN COUNTY

Most of Franklin County's covered bridge history involves the Sandy River. Col. Thomas Lancaster (1795–1881) of New Sharon was a prominent builder in the 1830s. Lancaster put up double-barrel covered bridges at several important locations. Historical accounts state that he used the Long truss, but this is not quite certain, and there are no photographs of his bridge interiors. Robinson A. Davis was later active in the area.

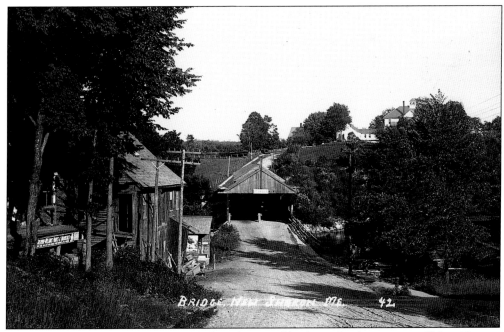

Col. Thomas Lancaster built a double-barrel covered bridge at his hometown of New Sharon, probably in 1830. The Sandy River is noted for flood trouble, and the bridge was several times repaired or at least partly replaced over the years. It was torn down in 1916 and replaced with a steel truss that still stands, although it is not in service. (Richard Sanders Allen Collection, NSPCB Archives.)

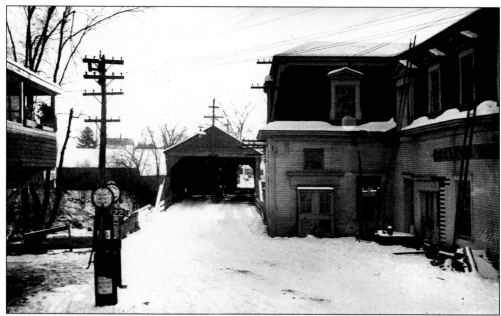

Farmington Falls was the site of another Lancaster bridge, built in 1831. Part or all of it may have gone out in 1850s floods. The south span was lost in 1869 but was rebuilt as a covered bridge. It survived the 1929 fire that destroyed the adjacent mill, but it was replaced by a concrete bridge in 1931. (Maine DOT files.)

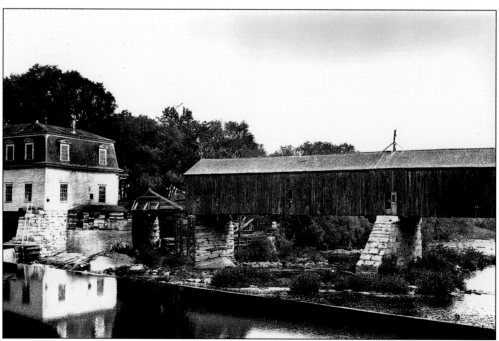

Note the open kingpost approach span to the covered bridge at Farmington Falls. (Maine DOT files.)

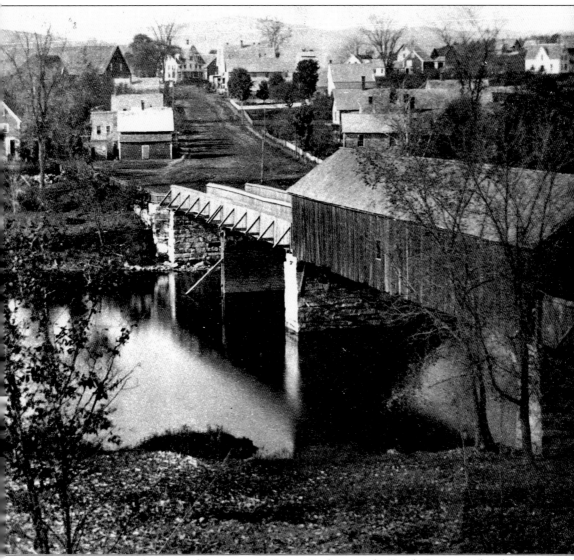

The original noncovered version of Farmington's Center Bridge over the Sandy River stood in the intervale just west of downtown, but the site was abandoned after 1814 because of flood trouble. A new location downstream near West Farmington was chosen. The early open bridge was replaced by a covered Long truss in 1831, probably by Col. Thomas Lancaster, although there is no known record. It was replaced again in the 1850s by Robinson A. Davis and was a double barrel. One span was later replaced with a two-lane boxed pony truss and an additional pier. The bridge is shown here in a view looking toward West Farmington. Since 1891, there have been several steel replacements, and the site was moved slightly downstream when the modern Center Bridge was built in 1991. (Richard Sanders Allen Collection, NSPCB Archives.)

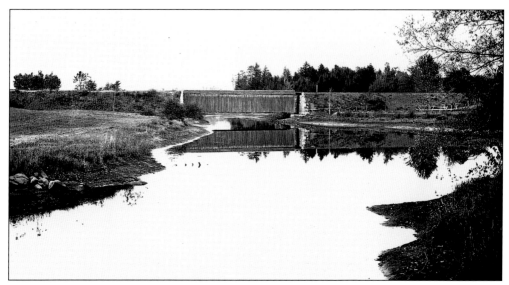

The famed Sandy River and Rangeley Lakes two-foot-gauge railroad had several covered bridges. This deck truss example crossed the Baker Stream at Fairbanks. There was briefly a covered highway bridge over the Sandy River at Fairbanks, although it was gone long before the railroad was built.

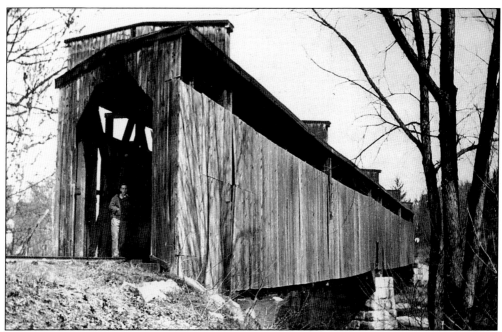

Betts Bridge served the Sandy River and Rangeley Lakes Railroad at Phillips. Built in 1890, it crossed the Sandy River not far from the downtown or Lower Village highway bridge. Another covered railroad bridge briefly stood at Salmon Hole about a mile south of the village, over the town line in Avon. (Michael DeVito Collection, NSPCB Archives.)

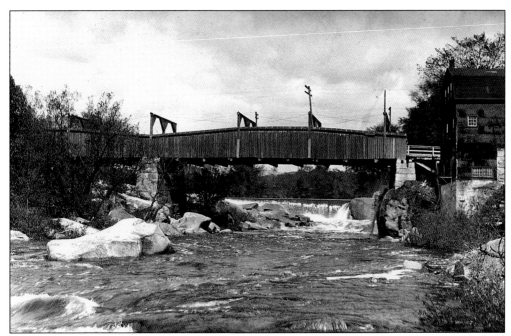

Before the 1869 flood, downtown Phillips (or Lower Village in old accounts) had a fully covered bridge over the Sandy River. In 1876, N.B. Beal built this two-lane boxed pony truss, which lasted until 1927. (Maine DOT files.)

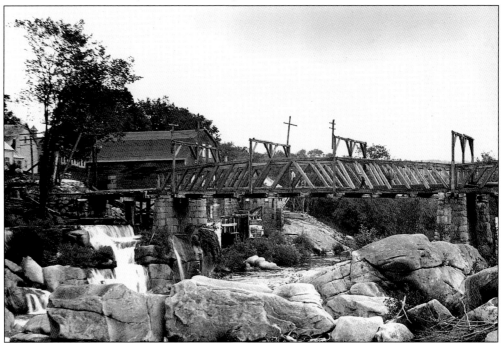

The 1927 demolition of Lower Village Bridge revealed the multiple-kingpost trusswork. The braces were dapped directly into the chords (top and bottom timbers of the truss), and the top chords were slightly arched. Its concrete replacement survived the devastating flood later that year and is still in service. (Maine DOT files.)

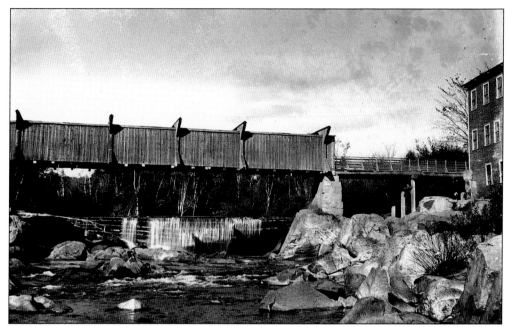

Ross Bridge crossed the Sandy River at the Upper Village, about a mile upstream from downtown Phillips. It was built in 1871 and was a boxed pony truss similar to Lower Village Bridge in appearance, but it seems to have had only one lane, and the top chords were straight. Photographs of the two bridges are often confused. (Maine DOT files.)

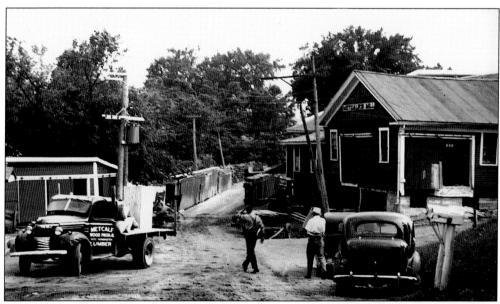

Much of Franklin County is an upland region whose small rushing streams were often narrow enough to be spanned by boxed pony trusses rather than fully covered through truss bridges. This example served Metcalf's Mill (or Walton Mill) over the Temple Stream in Farmington and was removed in 1948. The photograph was taken by Roy A. Wentzel on July 1, 1946. (Maine DOT files.)

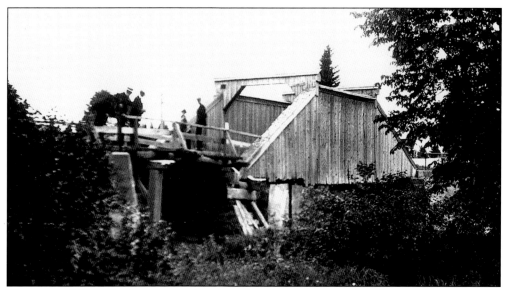

The town of Eustis had no covered bridges, but there were two boxed pony trusses over the various branches of the Dead River. This one crossed the South Branch just north of Stratton and was removed in 1922. (Maine DOT files.)

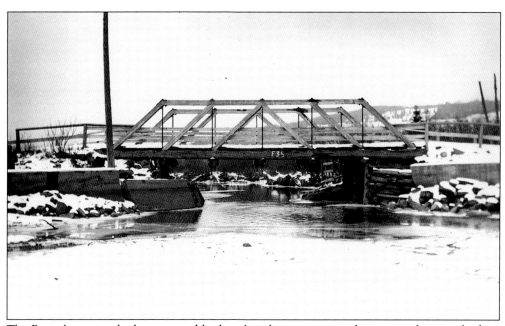

The Rangeley region had no covered bridges, but there were several open wooden truss bridges. This one crossed the Long Pond Stream near its mouth on Rangeley Lake. A little open kingpost bridge once served Edelheid Road (the former CCC Road) farther upstream. (Maine DOT files.)

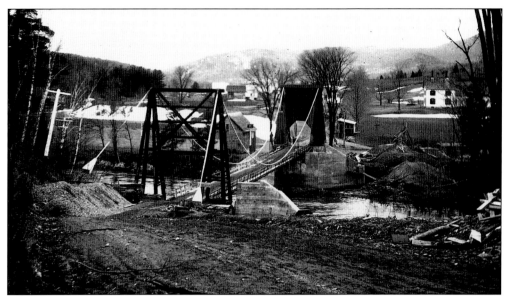

Strong had an elegant wire suspension bridge over the Sandy River, built in 1857 by Daniel Beedy. This photograph shows demolition beginning in 1922. (Maine DOT files.)

The Androscoggin River crosses the southern tip of Franklin County at Jay, where it divides into different channels around islands. The east channel had a fully covered bridge until the flood of 1896. The west channel had this strange structure, which appears to have been a combination of boxed pony trusswork and cable stays. Later, laminated arches were added too. Originally built in 1835, it survived until 1914. (Richard Sanders Allen Collection, NSPCB Archives.)

Five

KENNEBEC COUNTY

Timothy Palmer of Massachusetts built America's first known covered bridge at Philadelphia, opened in 1805. Eight years earlier, one Captain Boynton built a bridge over the Kennebec River at Augusta, Maine, using Palmer's trussed arch plan. However, it was not a covered bridge and succumbed to decay in 1816. It successor in 1818 was of similar construction, but covered. From that time on, Kennebec County saw a wide variety of covered bridge truss types over the Kennebec and its tributaries.

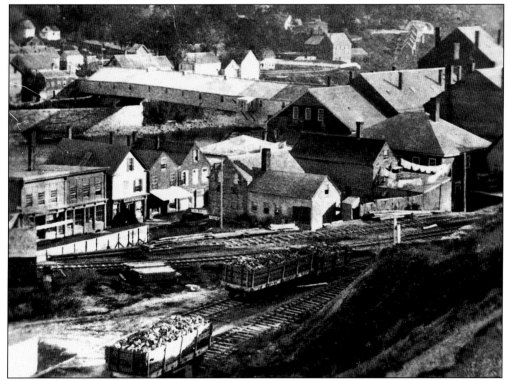

Kennebec Bridge at Augusta was Maine's first known covered bridge when built by Benjamin Brown and Ephraim Ballard Jr. in 1818. It burned down in 1827 and was replaced the same year by this covered bridge, which stood until 1890. The railroad tracks curving away to the left crossed the mighty Kennebec on a deck truss covered bridge from 1857 to 1870. (Richard Sanders Allen Collection, NSPCB Archives.)

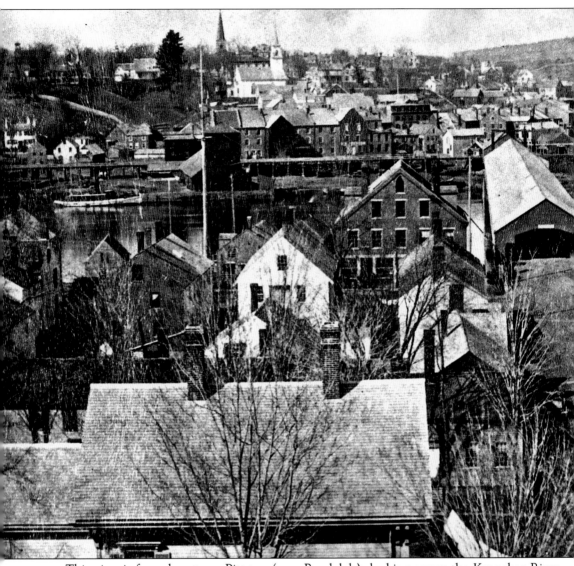

This view is from downtown Pittston (now Randolph), looking across the Kennebec River to Gardiner. The covered bridge, long opposed by maritime interests as an impediment to shipping, finally went up in 1852–1853. It was a Howe truss and wide enough for two lanes of traffic with no center truss. There were sidewalks on each side. The current bridge is upstream, and the site has much changed, but the large brick building just to the left of the bridge portal is still there. (Richard Sanders Allen Collection, NSPCB Archives.)

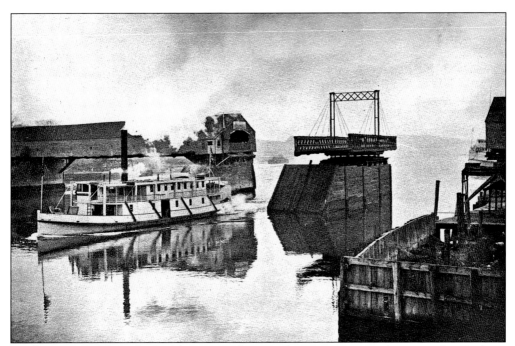

Gardiner-Randolph Bridge had four covered spans, plus an open swing draw near the Gardiner shore. (Richard Sanders Allen Collection, NSPCB Archives.)

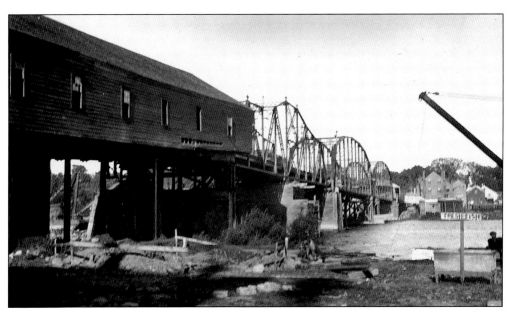

The 1896 flood took out the center spans of Gardiner-Randolph Bridge, which were later replaced with steel trusses. One covered span remained at each end until 1926. (Maine DOT files.)

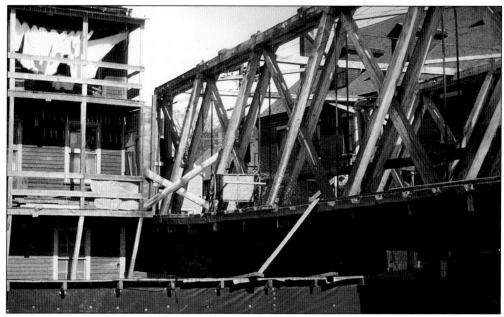

Demolition was in progress on May 13, 1926, at the original covered portions of Gardiner-Randolph Bridge. The Howe trusses are clearly revealed; note the vertical iron rods that were such an important feature of this design. (Maine DOT files.)

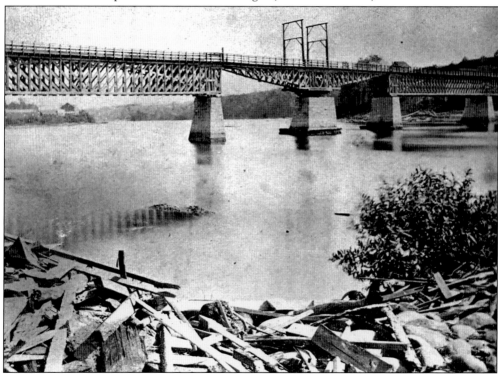

Hallowell briefly had a bridge over the Kennebec to Chelsea, built in 1860 on the extremely rare Hall truss plan. Never covered, it soon decayed and was lost to an ice jam in 1870. There is no bridge between Hallowell and Chelsea today. (Maine Historic Preservation Commission.)

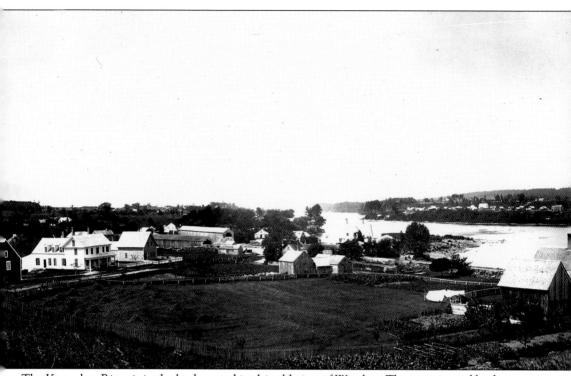

The Kennebec River is in the background in this old view of Winslow. The two covered bridges crossed the mouth of the Sebasticook River. To the left is the highway bridge built in 1834. Legend states that a wedding was once performed on it. To the right is a covered railroad bridge, probably built in the 1850s. (Richard Sanders Allen Collection, NSPCB Archives.)

The 1901 flood took out the covered bridge over the mouth of the Sebasticook River in Winslow, smashing it against the railroad bridge, which by then was a steel truss. (Richard Sanders Allen Collection, NSPCB Archives.)

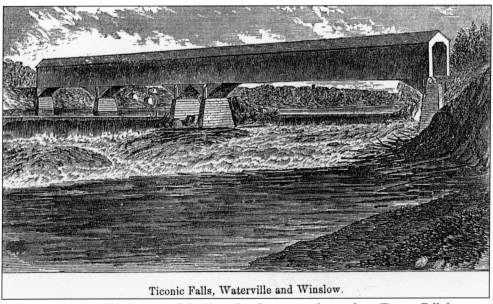

Ticonic Falls, Waterville and Winslow.

This covered railroad bridge crossed the Kennebec River on a skew right at Ticonic Falls between downtown Waterville and Winslow. Built in the early 1850s for the Kennebec and Portland Railroad, it was lost to the 1869 flood. (Richard Sanders Allen Collection, NSPCB Archives.)

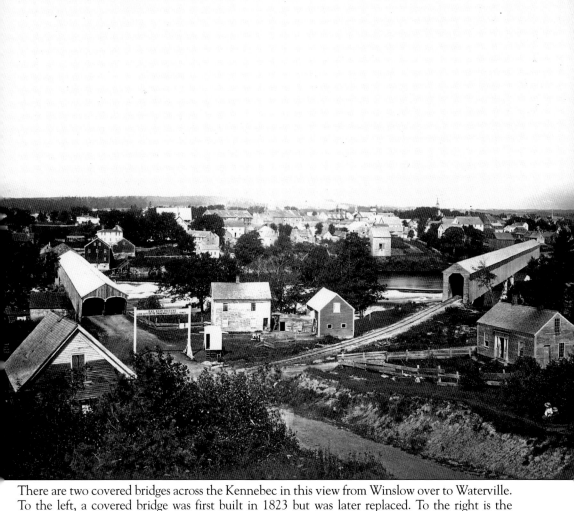

There are two covered bridges across the Kennebec in this view from Winslow over to Waterville. To the left, a covered bridge was first built in 1823 but was later replaced. To the right is the covered railroad bridge also pictured on page 54. Both bridges went out in the 1869 flood. The highway bridge floated off and was a serious threat to all bridges downstream, but a crew of men from Augusta came up by train and secured the wreckage where it had temporarily snagged in Vassalboro. (Richard Sanders Allen Collection, NSPCB Archives.)

Between Benton (Kennebec County) and Fairfield (Somerset County), the Kennebec River divides into three channels. The view is looking down Benton Hill to a double-barrel covered bridge crossing to Bunker's Island. The road then curves right, and you can just see part of the side and roof of a second covered bridge between Bunker's Island and Mill Island. These two bridges were built in 1848 and lasted into the 1890s. From Mill Island to Fairfield there was a third bridge, but that one was probably never covered. (Maine Historic Preservation Commission.)

Six

LINCOLN AND WASHINGTON COUNTIES

Maine's central and eastern coast never had many covered bridges. The mouths of major rivers such as the Penobscot were too large and deep to be spanned by 19th-century truss bridges, and many of the other streams were too small to require them. However, there were some distinctive structures whose memory is preserved in the photographic record.

Several far-flung railroad lines served the coast, and some of them had covered bridges. This example was over the Sheepscot River at Rosicrucian Springs, northeast of Wiscasset. (Richard Sanders Allen Collection, NSPCB Archives.)

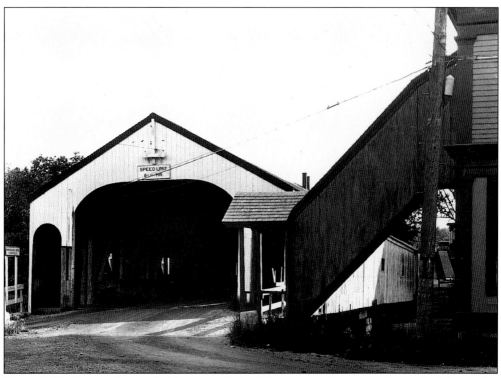

Cherryfield's Lower Corner Bridge crossed the Narraguagus River on Route 1 right in the middle of the village. (Richard Sanders Allen Collection, NSPCB Archives.)

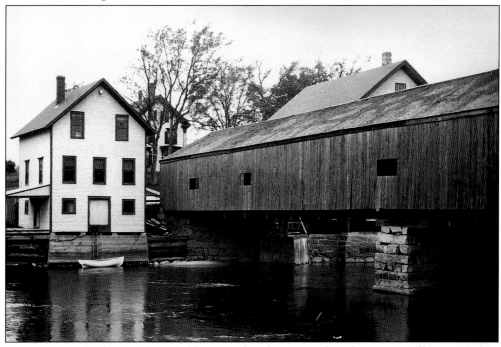

Lower Corner Bridge in Cherryfield was replaced in 1936, but the site is still recognizable. (Maine DOT files.)

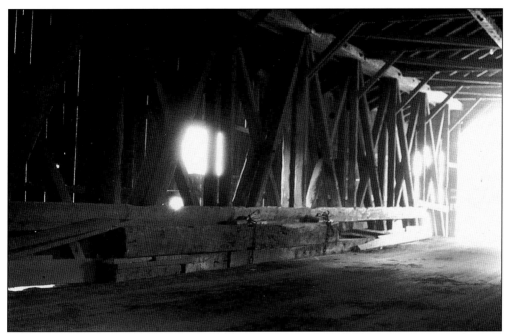

This rare interior view of Lower Corner Bridge in Cherryfield shows its Long trusses, built in 1843. (Maine DOT files.)

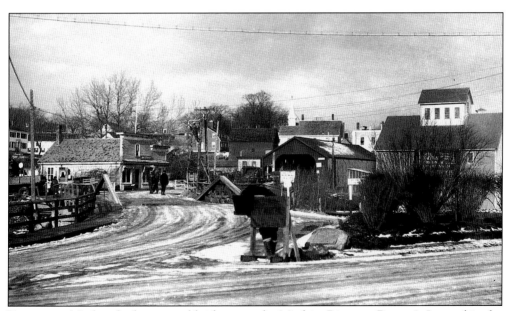

Downtown Machias had a covered bridge over the Machias River on Route 1. It stood in the midst of a maze of approach roads, served by little open kingpost trusses over side channels of the river. (Maine DOT files.)

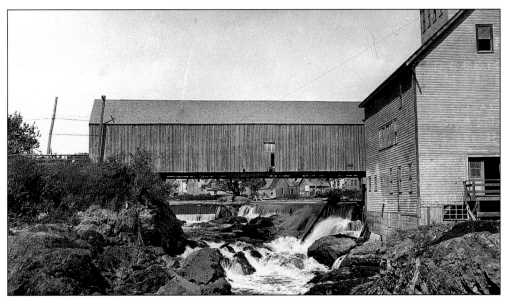

The covered bridge at Machias stood next to Getchell's Grist Mill (right), whose foundations are now part of Bad Little Falls Park. This view dates from 1924. (Maine DOT files.)

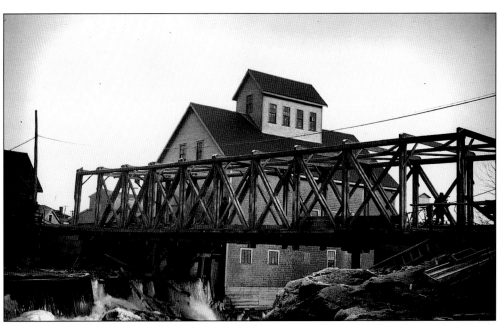

The Machias covered bridge was a Long truss built in 1842. This 1933 demolition photograph shows the structure clearly. (Maine DOT files.)

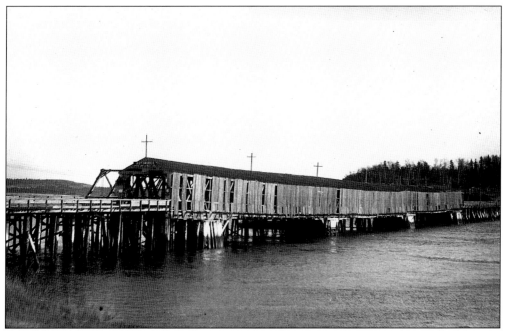

Between Eastport and Perry was a 527-foot covered bridge over a tidewater channel known as Bar Harbor. It was a toll bridge until 1914. The total length, including the open trestle approaches, was 1,209 feet. This view also shows an open wooden truss bridge built alongside to replace it in 1923. (Maine DOT files.)

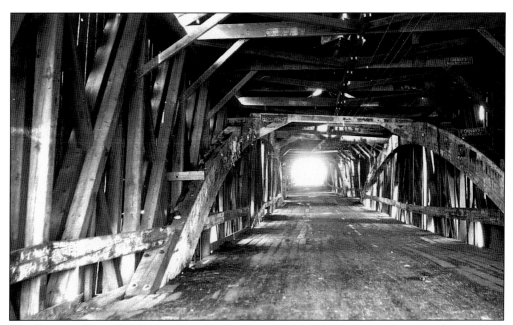

The Eastport-Perry Toll Bridge was a Long truss, to which laminated arches were later added. A construction date of 1820 is sometimes given, but since the Long truss had not yet been invented, this structure was obviously a later replacement. (Maine DOT files.)

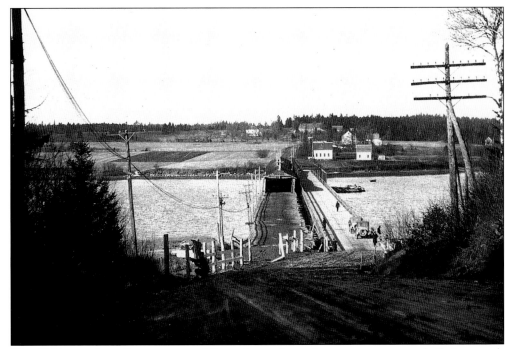

This 1924 view from Eastport toward Perry shows the replacement open truss built just north of the covered bridge, which is about to be removed. There is no bridge here today, because the state highway was relocated north across Carlow Island in 1956, and the former crossing was discontinued shortly afterward. (Maine DOT files.)

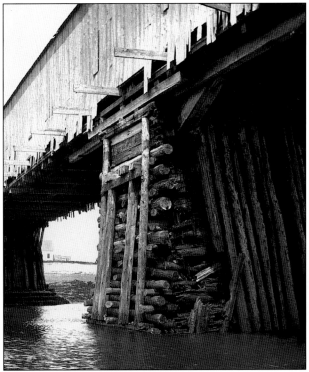

The piers of Eastport-Perry Toll Bridge were wood cribs, which had to be repaired constantly because of damage from decay, winter ice, and the action of the tides. (Maine DOT files.)

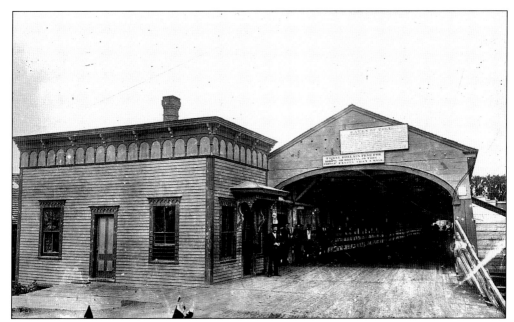

The St. Croix River had at least three international covered bridges crossing to Canada. The Ferry Point Bridge connected downtown Calais with St. Stephen. Here we see the U.S. entrance, with the customs and toll house to the left. The bridge was a Long truss built in 1845 and removed in 1894. P.T. Barnum's circus once crossed here, including Jumbo the Elephant. (Richard Sanders Allen Collection, NSPCB Archives.)

Milltown, Maine, was the site of another international covered bridge, crossing the St. Croix River to Milltown, New Brunswick. Known as Old Arch Bridge, it was said to have been built in the 1826–1830 period and thus would not have been a Long truss. It was replaced c. 1906. This view is from the Maine side. (Richard Sanders Allen Collection, NSPCB Archives.)

The coastal region had a number of boxed pony trusses. Head Tide Bridge, over the Sheepscot River in the town of Alna, is pictured in 1944. (Maine DOT files.)

Seven
OXFORD COUNTY

Oxford County had a quarter of Maine's known covered bridges and now has more than half the existing examples. It is a far-flung region including not only part of the Saco valley and the Oxford Hills but also much of the Western Mountains area. The Town lattice truss was early used here, but Peter Paddleford built some prominent bridges in Fryeburg in the 1840s, and his truss type became the standard in the county. It was still being used by local builders throughout the 1890s, long after Paddleford's death in 1859. The Grand Trunk Railway had McCallum truss bridges, both deck and through type and probably covered, at West Bethel, Locke Mills, Bryant Pond, West Paris, and South Paris.

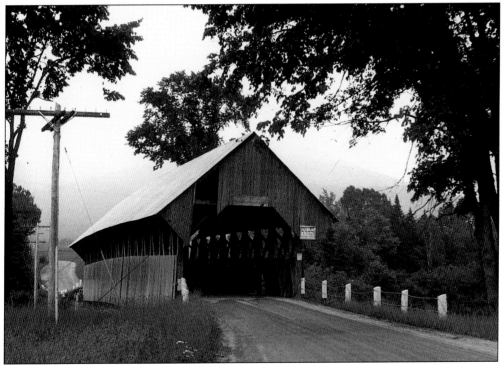

Olson Bridge spanned the Magalloway River at Wilsons Mills. Originally it was on a dead-end road that went as far as Aziscohos Dam, and access to the region was only through New Hampshire. The road was later extended through to the Rangeley region and became part of Route 16. Covered bridge historian Richard Sanders Allen took this photograph on July 27, 1938. (NSPCB Archives.)

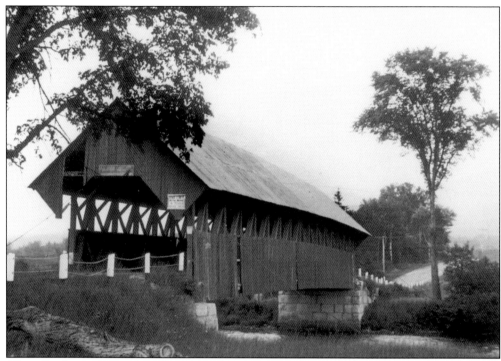

Olson Bridge at Wilsons Mills was built in 1897 and was quite similar in appearance to the existing Bennett Bridge, a little over a mile downstream over the Magalloway River. Both were Paddleford trusses, but Olson was slightly longer and had an extra truss panel of shorter length at each end. This photograph was taken by Richard Sanders Allen on July 27, 1938. (NSPCB Archives.)

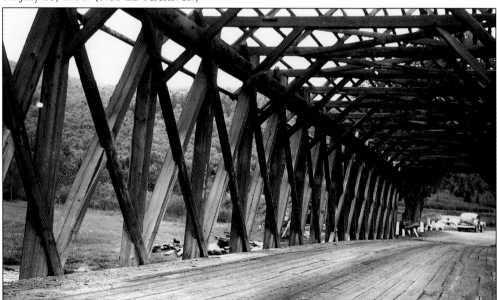

Olson Bridge is being removed in this photograph taken by Roy A. Wentzel on June 16, 1948. It was replaced by a Bailey bridge that was supposed to be temporary but ended up serving for 20 years. (Maine DOT files.)

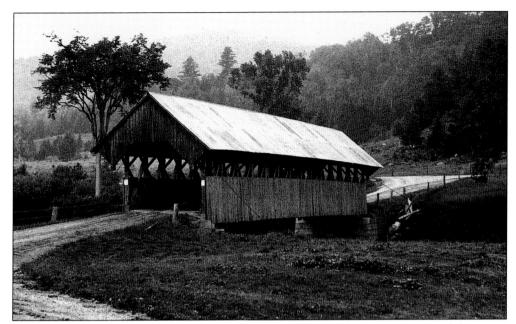

Bennett Bridge still spans the Magalloway River on a side road about a mile south of the center of Wilsons Mills, but it has been closed since 1985. This photograph taken by Richard Sanders Allen on July 27, 1938, shows one of the elm trees that stood majestically here and there in the valley until the 1970s. (NSPCB Archives.)

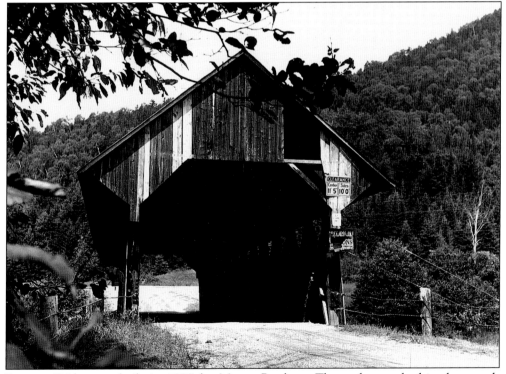

Bennett Bridge was built in 1898 by Mason Brothers. The author took this photograph on July 24, 1974.

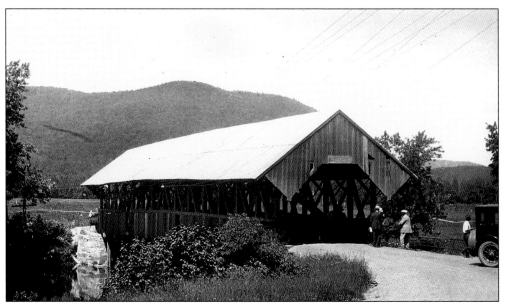
Brown Farm Bridge spanned the Magalloway River at Magalloway, near the New Hampshire state line. It is thought to have been built in 1877. (Maine DOT files.)

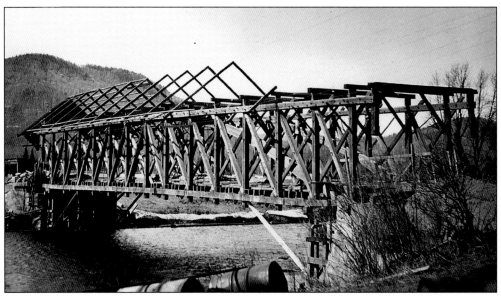
This view during removal of Brown Farm Bridge on April 5, 1925, shows the Paddleford trusses. The arch may have been original but was more likely a later addition. (Maine DOT files.)

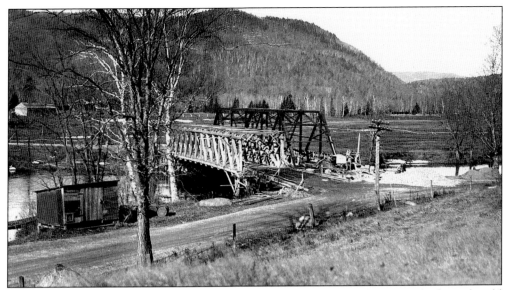

During replacement, Brown Farm Bridge was moved aside and a steel truss was built on the old abutments. The steel truss was removed in 1974, when a new bridge was built upstream, but the abutments can still be seen. This view dates from October 15, 1925. (Maine DOT files.)

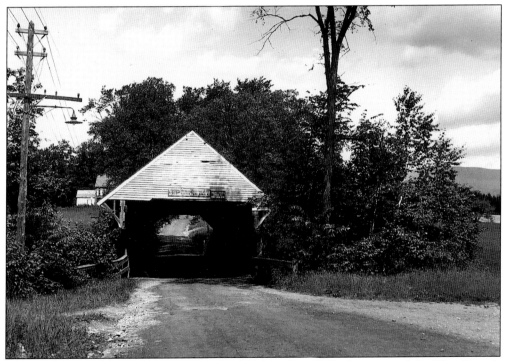

Andover once had four covered bridges. Brickett's, or Rand's, Bridge spanned the West Branch of the Ellis River just north of the village. The photograph was taken by Richard Sanders Allen on July 31, 1940. (NSPCB Archives.)

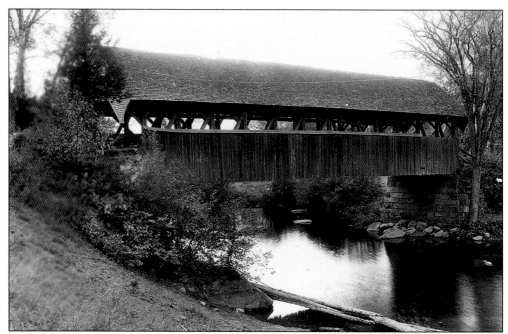

This is another view of Brickett's Bridge in Andover, built in 1871 and removed in 1948. The Paddleford truss evidently became understood as a generic type, and one old account quaintly notes that this bridge was built on the "paddle foot model." (Richard Sanders Allen Collection, NSPCB Archives.)

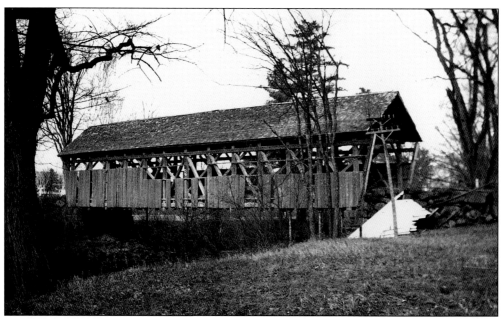

Another "paddle foot" (Paddleford) truss was Merrill Bridge, over the West Branch of the Ellis River about half a mile east of Andover. It was built in 1870 and replaced in 1935. (Maine DOT files.)

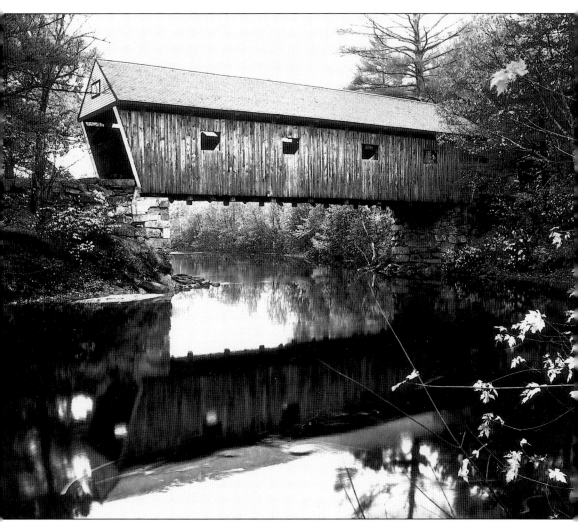

Andover still has Lovejoy Bridge, a Paddleford truss over the Ellis River about three miles south of the village. Built in 1867, it survived the great 1869 flood that destroyed the predecessors to both Brickett's and Merrill Bridges in town. The Ellis River makes a sharp bend here, and floodwaters usually wash away the road just east of the bridge instead of taking out the bridge itself. The author took this photograph on October 13, 1985.

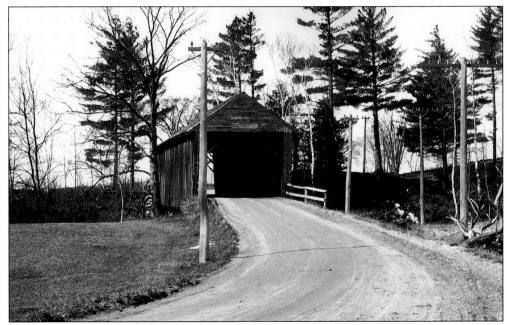

It is hard to believe, but this is Route 2 west of Rumford Point. Martin's Bridge carried the highway over the Ellis River until c. 1928. It was a Town lattice truss, but the planks were oriented more toward the vertical than is usual for the type. (Maine DOT files.)

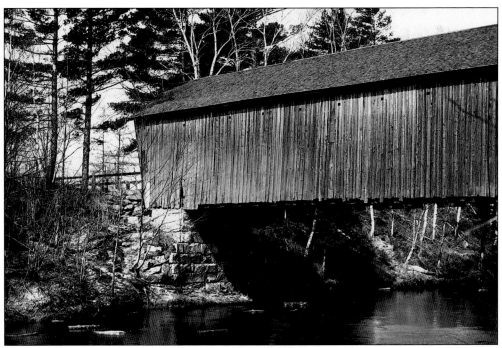

This is a side view of Martin's Bridge over the Ellis River west of Rumford Point in its last days. (Maine DOT files.)

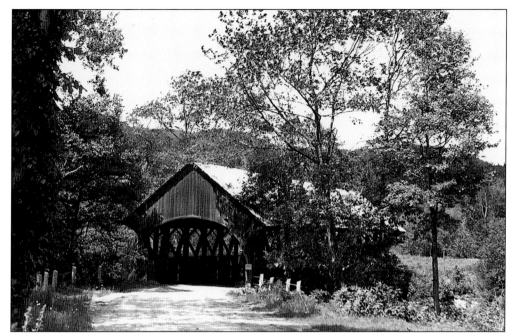

The existing Sunday River Bridge in Newry was one of the best-known covered bridges in New England, even before the nearby ski area was built. The former name of the road here was Ketchum Road. This photograph was taken by Richard Sanders Allen on July 31, 1940. (NSPCB Archives.)

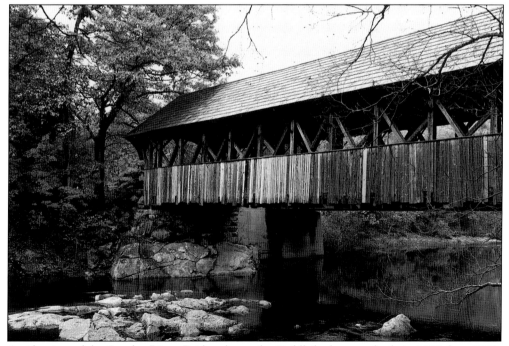

A side view of the Sunday River Bridge shows the Paddleford trusses built in 1872 (not 1870, as is sometimes stated). Streamside ledge provides a convenient foundation. The author took this photograph on October 14, 1985.

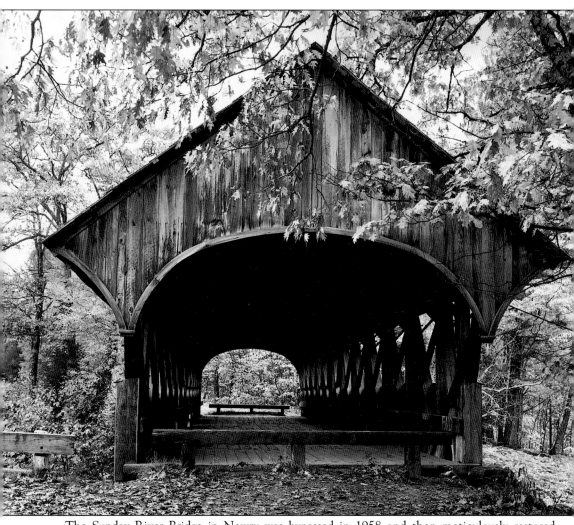

The Sunday River Bridge in Newry was bypassed in 1958 and then meticulously restored. Originally the portal boarding on the part projecting beyond the bridge sides was on a diagonal, but other than that, if builder Hiram York could come back today, he might think he had left off work just a short time ago.

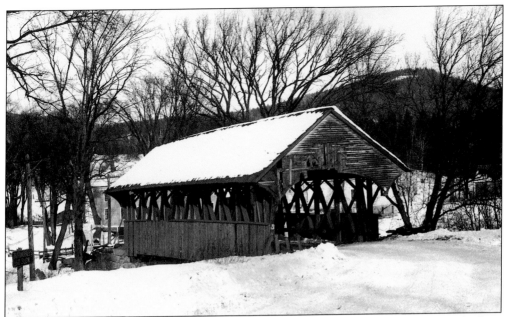

The history of Bear River Bridge on Route 2 in Newry is sketchy, but it was probably built in 1869 by Hiram York. Another Paddleford truss, the portal was finished in narrow clapboards. This view dates from 1928, and the bridge was removed the next year. It was partly in Newry, partly in Bethel, and partly in Hanover. (Maine DOT files.)

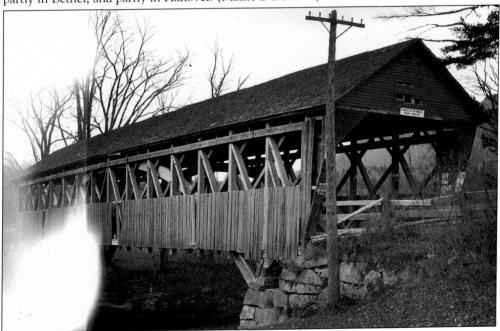

This is the former Sunday River Bridge on Route 2 in Bethel, not to be confused with the existing bridge of the same name upstream in Newry. Photographs are sometimes confused, but the one in Bethel had a much smaller roof overhang, with different portals, and it had a laminated arch in addition to the Paddleford trusses. The photograph dates from 1924, and the bridge was removed in 1927. (Maine DOT files.)

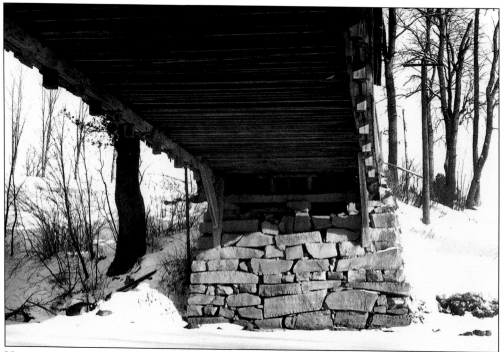

Here is a rare view underneath the former Sunday River Bridge on Route 2 in Bethel. (Maine DOT files.)

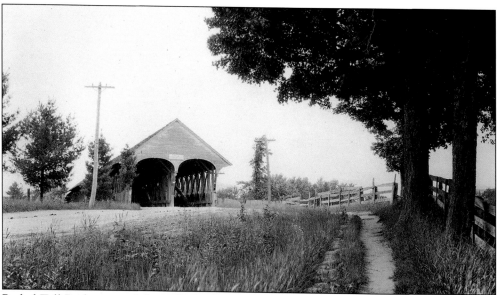

Bethel Toll Bridge crossed the wide Androscoggin River at the locality of Mayville, just north of Bethel. This view of the south portal shows the double-barrel entrance. (Richard Sanders Allen Collection, NSPCB Archives.)

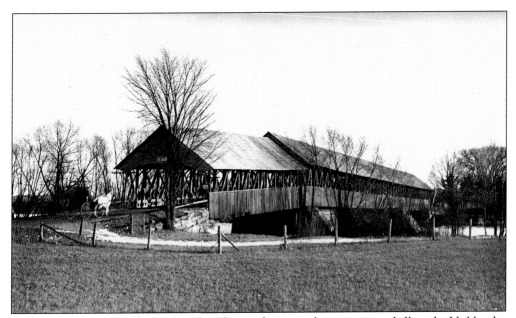

Bethel Toll Bridge had three spans, but the north approach was on an uphill angle. Unlike the other end, it had a wide single entrance. The bridge was built in 1868–1869, but accounts differ as to the builder. This view dates from 1925. (Maine DOT files.)

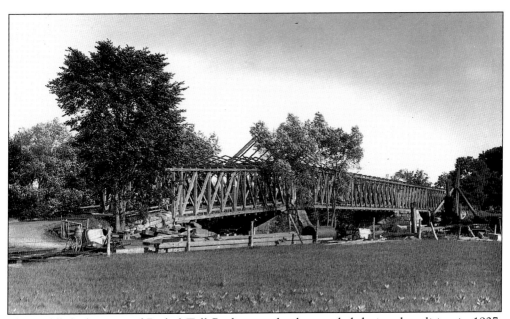

The Paddleford trusses of Bethel Toll Bridge are clearly revealed during demolition in 1927. (Maine DOT files.)

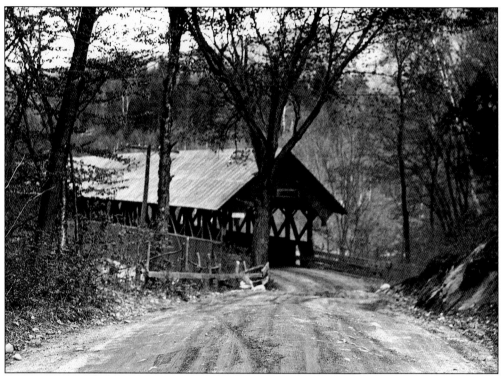
A two-span Paddleford truss crossed the Wild River in Gilead, and again it is hard to believe that this is Route 2. The bridge was built in 1868 and lasted 60 years. (Maine DOT files.)

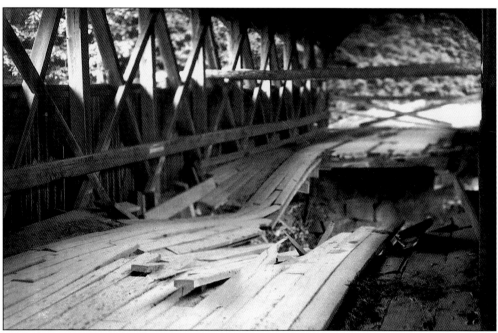
A truck went through the floor of Wild River Bridge in Gilead in 1926, and the bridge was torn down two years later. (Maine DOT files.)

Park Street Bridge in South Paris spanned the Little Androscoggin River from 1855 to 1896. (Verna Gatchell Collection, NSPCB Archives.)

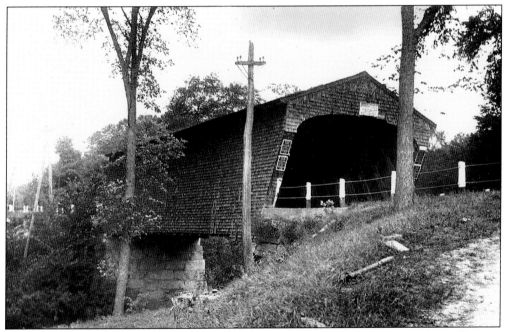

The town of Oxford had three covered bridges, all over the Little Androscoggin River. Stanton Bridge was on Route 26 about two miles south of Norway. It was a Town lattice truss built in the late 1830s, and it stood until 1932. One portal was overhung, as in this view, but the other end was straight up and down. This oddity is thought to have resulted from repairs after the 1869 flood. (Photograph by Basil Kievit from Richard Sanders Allen Collection, NSPCB Archives.)

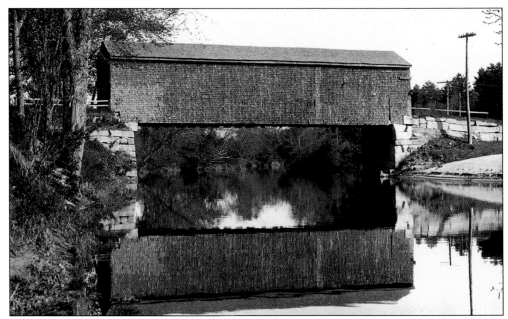

Oxford Village Bridge was on Route 121 just northeast of the village center. It was built in 1839 and lasted 101 years. The fully shingled housing style was never common but was found occasionally on covered bridges in Maine and Nova Scotia. (Maine DOT files.)

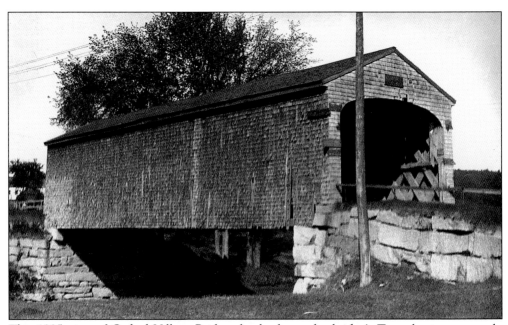

This 1925 view of Oxford Village Bridge clearly shows the bridge's Town lattice trusswork. Both portals were straight up and down; compare this image with the view of Stanton Bridge on page 79. (Maine DOT files.)

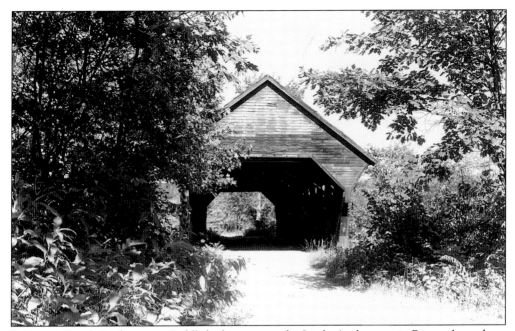
Sebastian Smith Bridge was a Paddleford truss over the Little Androscoggin River, about three miles north of Oxford. (Richard Sanders Allen Collection, NSPCB Archives.)

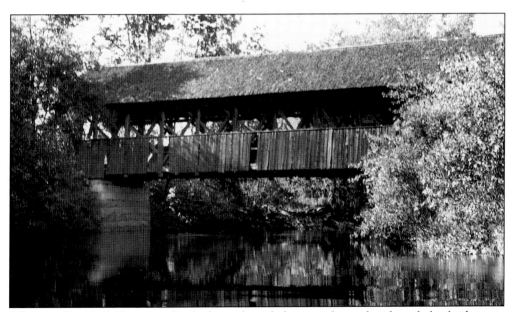
Sebastian Smith Bridge served a little-used road that was later closed, and the bridge was removed in the 1930s. This photograph dates from 1924. (Maine DOT files.)

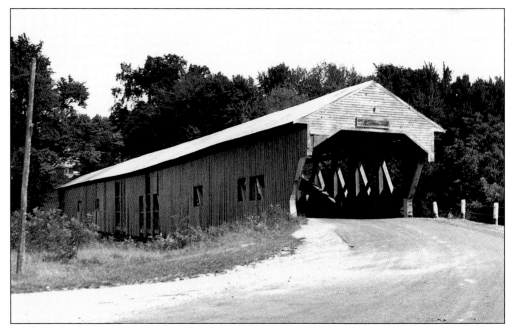

Fryeburg had seven covered bridges, more than any other Maine town. Weston's Bridge was just west of the village. Built in 1844 by Peter Paddleford himself, this was the first known bridge in which he used his newly invented truss. (Richard Sanders Allen Collection, NSPCB Archives.)

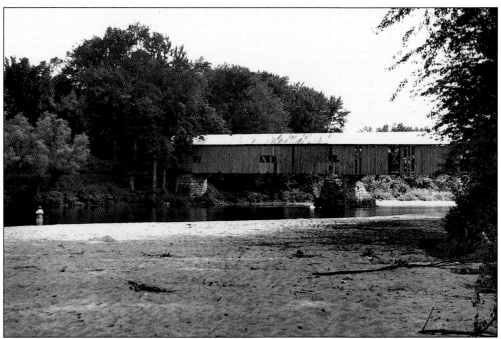

Weston's Bridge in Fryeburg crossed the Saco River at a popular swimming hole. It was replaced in 1947, but remains of the abutments and pier may still be seen. (Richard Sanders Allen Collection, NSPCB Archives.)

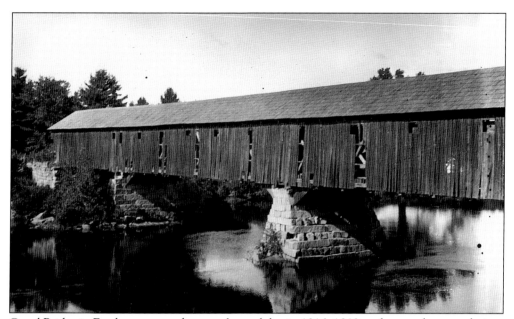
Canal Bridge in Fryeburg spanned a new channel dug in 1816–1819 to shorten the meanderings of the Saco River in town. During an 1820 freshet, the main flow of the river switched over permanently to the canal. The covered bridge was another Paddleford truss, put up in 1846 by the great builder Peter Paddleford himself. (Maine DOT files.)

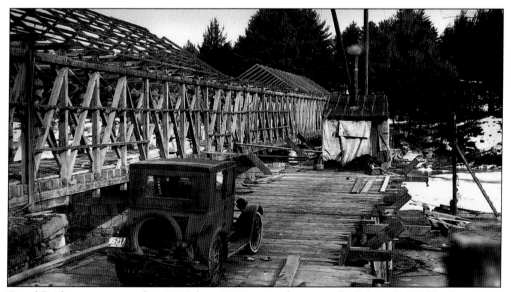
Canal Bridge was removed in 1929 (not 1932, as is often stated). (Maine DOT files.)

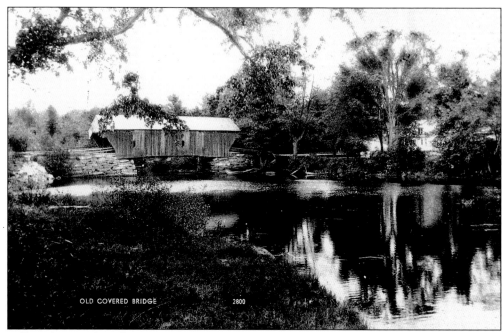

Toll Bridge stood on the same road as Canal Bridge, which is today's Route 5, but about three miles farther north. It crossed the Old Course Saco River, but there is very little volume of water flowing here, which explains why such a short bridge was used for such a wide stream. (Richard Sanders Allen Collection, NSPCB Archives.)

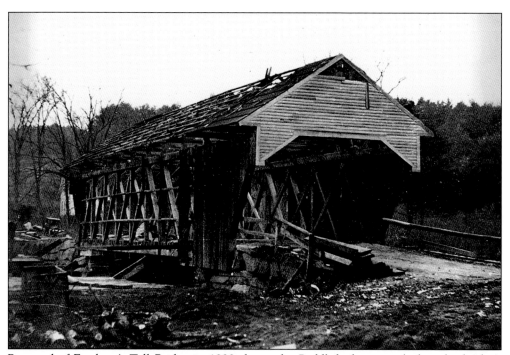

Removal of Fryeburg's Toll Bridge in 1929 shows the Paddleford trusswork, but the bridge's history is little known. (Maine DOT files.)

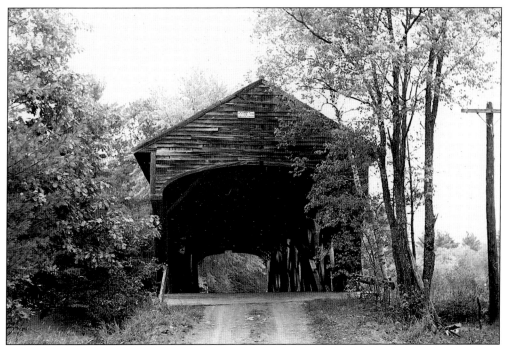

Hemlock Bridge still stands on a little used road that connects the Toll Bridge area with East Fryeburg. It was built in 1857 over the Old Course Saco River and has been restored since this 1952 view by Lucy Loekle Kemp. (NSPCB Archives.)

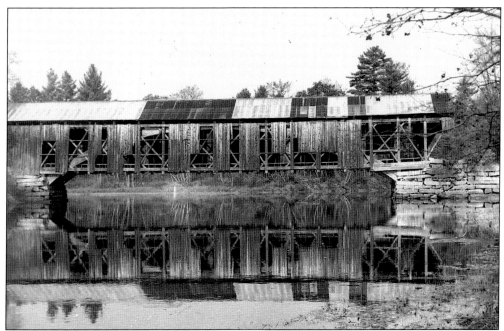

Another view of Hemlock Bridge in Fryeburg shows it as it was before restoration. The Paddleford trusses can be seen behind the missing side boards. (Photograph by Verna Gatchell from Lucy Loekle Kemp Collection, NSPCB Archives.)

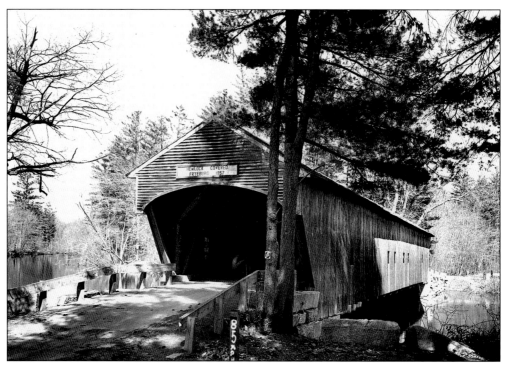

A 1998 view shows that Hemlock Bridge is now kept in very good repair. However, hidden steel beams have carried the live load since 1987.

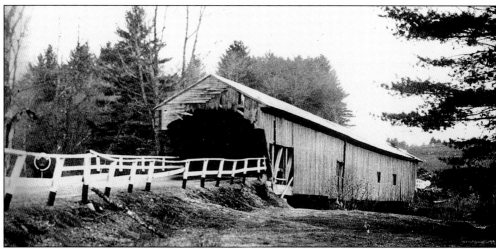

Walker's Bridge, on Route 302 east of Fryeburg village, was built in 1848 by Peter Paddleford. It crossed the main channel of the Saco River, below the point at which the Old Course rejoins the canal. This photograph dates from 1931 just before replacement. (Maine DOT files.)

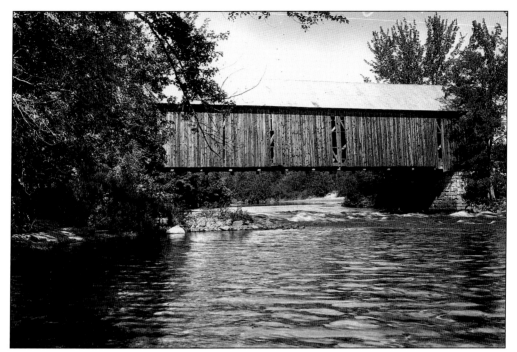

Walker's Island Bridge was over the Saco in a remote region about two miles downstream from the similarly named Walker's Bridge. It was a Paddleford truss dating from 1862. It went out in the 1936 flood and was not replaced, but the abutments may still be seen. (Maine DOT files.)

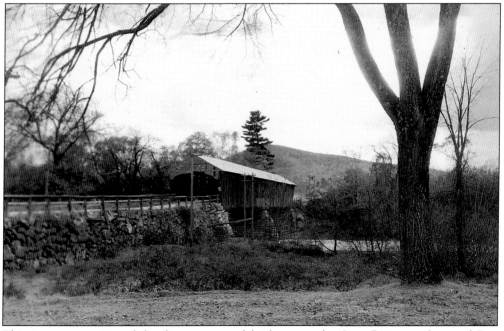

This is a scarce view of the former covered bridge over the Saco River northeast of East Brownfield. It was a Paddleford truss built in 1854 and was lost to the 1936 flood. (Lucy Loekle Kemp Collection, NSPCB Archives.)

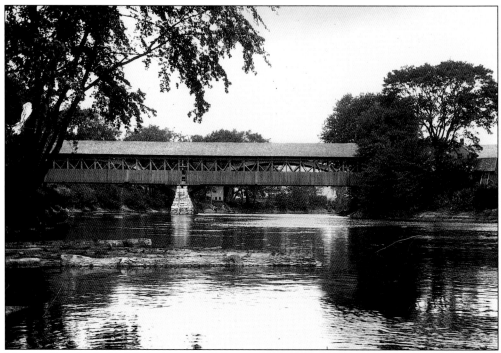
Hiram village had a Paddleford truss with laminated arches over the Saco River to East Hiram, built in 1859. The contractor for its replacement in 1928 kidded the state engineer, saying, "In the old days, real men built these bridges. Now they use engineer!" (Maine DOT files.)

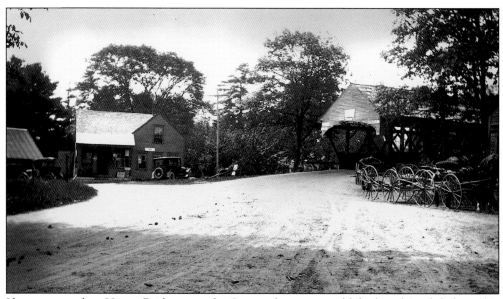
If you returned to Hiram Bridge over the Saco today, you would find nothing left from this undated old view. (Maine DOT files.)

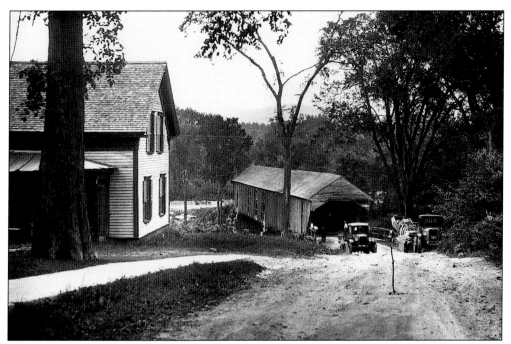

There was another Hiram Bridge just outside Cornish, over the Ossipee River on the York County line. This photograph shows replacement work on August 23, 1930. (Maine DOT files.)

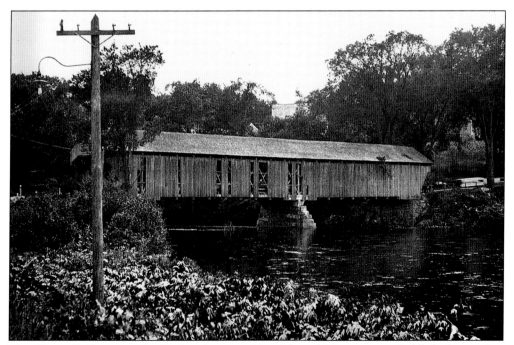

The Hiram Bridge over the Ossipee between Cornish and Hiram was a Paddleford truss, but its history is little known because it has often been confused with other covered bridges. (Maine DOT files.)

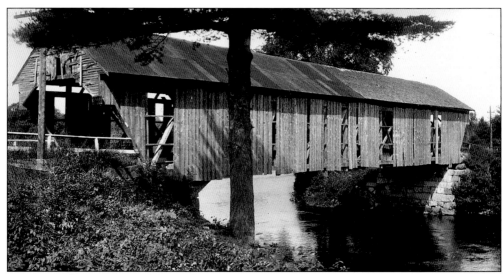
Warren Bridge was west of Cornish, over the Ossipee River to Hiram, on the York-Oxford county line. (Maine DOT files.)

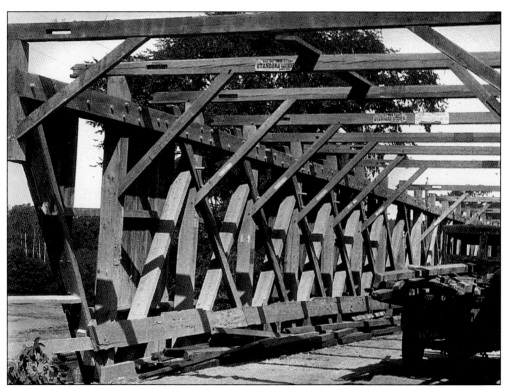
Warren Bridge was replaced in 1929, and this demolition view shows the Paddleford trusses. (Maine DOT files.)

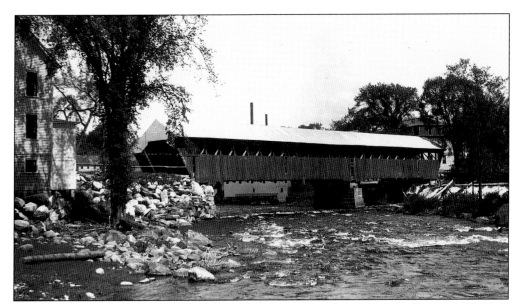

The village of Kezar Falls is partly in Porter (Oxford County) and partly in Parsonsfield (York County). This Paddleford truss covered bridge was built in 1869 to connect the two parts of the village and was replaced in 1924. (Maine DOT files.)

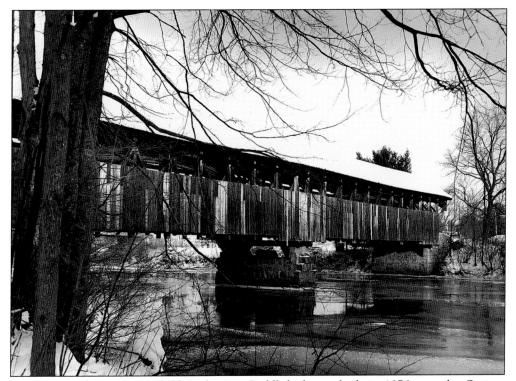

The existing Porter-Parsonsfield Bridge is a Paddleford truss built in 1876 over the Ossipee River, just south of the village of Porter.

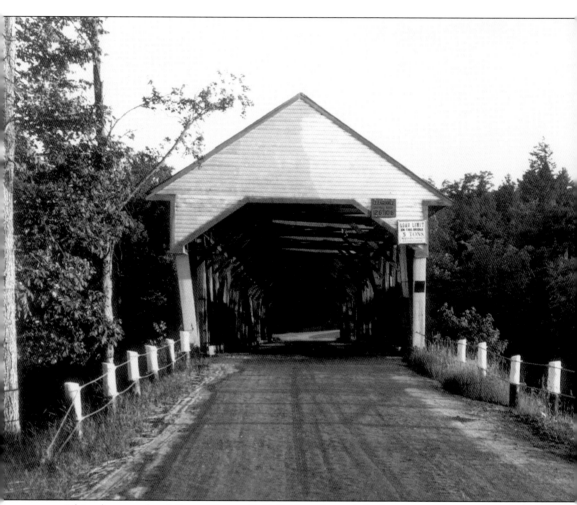

This photograph of Porter-Parsonsfield Bridge shows it before it was bypassed in 1960. For some years, its deck was paved with rectangular asphalt blocks. (Richard Sanders Allen Collection, NSPCB Archives.)

Eight
PENOBSCOT COUNTY

The Penobscot valley was important in Maine's lumber business, and the region also had some early covered bridges. Capt. Isaac Damon brought the Town lattice truss to the attention of area builders, while the bridges on the Military Road demonstrated the strength of the Long truss. Later on, the Howe truss proved popular both for railroad and for highway bridges. Penobscot County's last covered bridge, at Robyville in the town of Corinth, is a fine example of the Long truss and is Maine's only remaining all-shingled bridge.

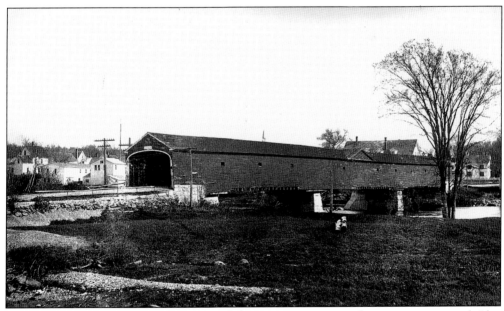

Mattawamkeag Bridge, over the river of the same name, was the most important bridge built for the Military Road from Bangor to Houlton. Constructed under the supervision of Capt. Charles Thomas in 1831, it closely followed the 1830 patent of fellow army man Lt. Col. Stephen H. Long. The original Long patent had a superfluous kingpost frame above the top chords. In practice it was soon eliminated, but Mattawamkeag Bridge was early enough to have had this feature in its center span. (Maine DOT files.)

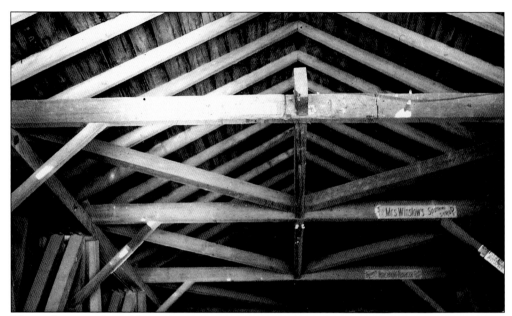

This is the upper lateral bracing of Mattawamkeag Bridge, which was torn down in 1928. Note the advertisement for Mrs. Winslow's Soothing Syrup. Posters for this product could once be found in covered bridges as far away as southwestern Vermont. (Maine DOT files.)

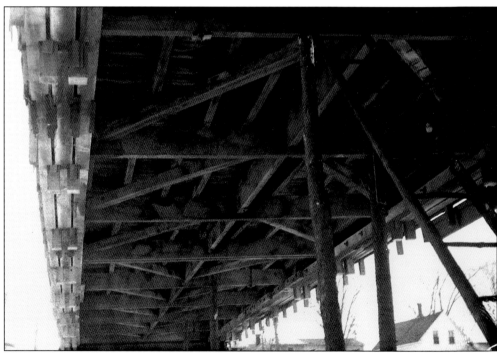

The spans of Mattawamkeag Bridge were long enough to have included a lower lateral bracing system under the deck. Some covered bridges of shorter span lacked this feature, and all that could be seen underneath were the floor beams (see pages 33 and 76). These three photographs of Mattawamkeag Bridge date from 1923–1924. (Maine DOT files.)

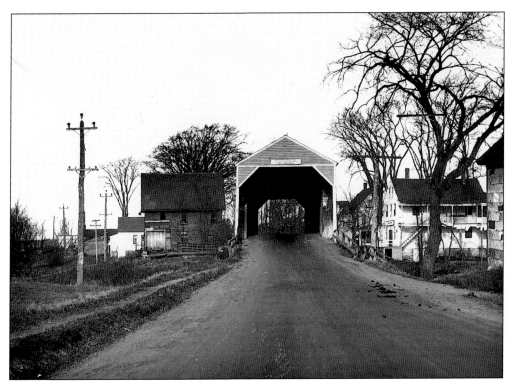

Passadumkeag Bridge was also on the Military Road, but there is no record of the original structure. It was probably a Long truss, as was this later replacement, which lasted until 1930. (Maine DOT files.)

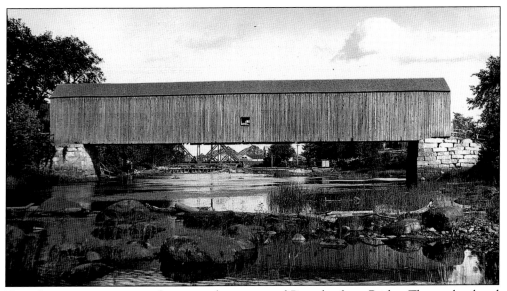

Note the impressive granite abutments that supported Passadumkeag Bridge. The steel railroad bridge in the background is still there. (Maine DOT files.)

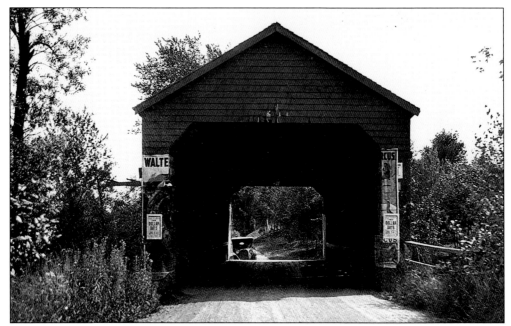

Irving Bridge crossed the Pushaw Stream on Bennoch Road in the western outskirts of Old Town. The original covered bridge was an 1831 product of noted builder Edward R. Southard, but this is a later replacement. Records are unclear, but it seems to have been a Howe truss. This is a 1924 view. (Maine DOT files.)

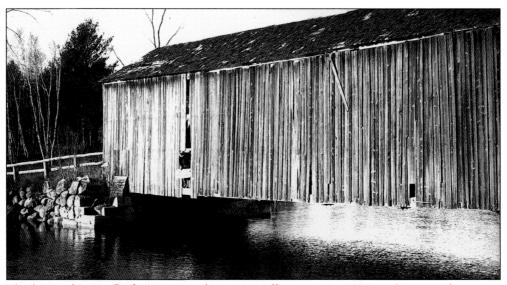

The bases of Irving Bridge's granite abutments still support its 1937 steel truss replacement. They are unusually wide, and if they came from the original covered bridge, it may have been a double barrel. (Maine DOT files.)

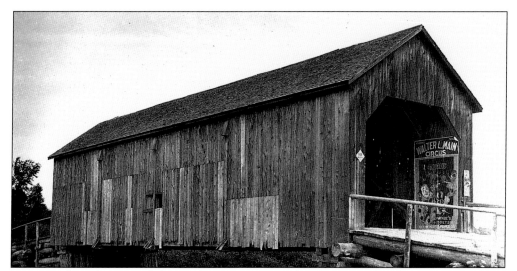

Boom Birch Bridge crossed the Birch Stream in an isolated section of Old Town, on the shore of the Stillwater River. It was a queenpost truss built in 1899 and removed in 1938. This is how it looked in 1924. (Maine DOT files.)

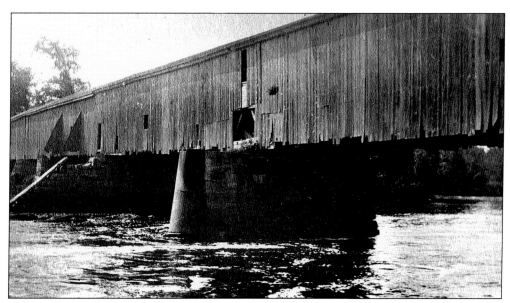

Gilman Falls Bridge crossed the Stillwater River west of downtown Old Town on what is now Route 43. It was an impressive 325-foot structure of unknown type and was removed in 1919. This is the only photograph the author has ever seen of it. (Maine DOT files.)

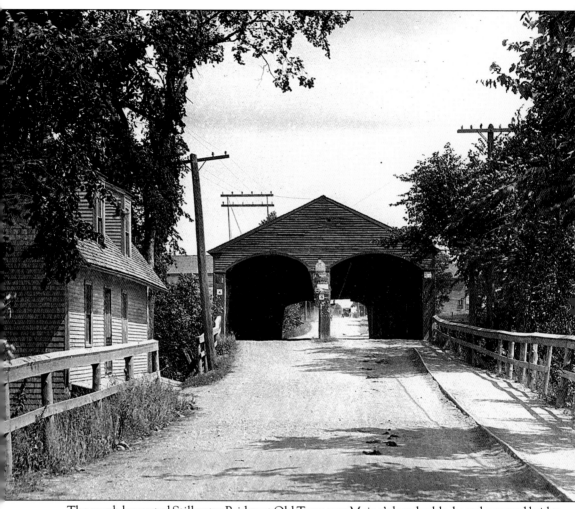

The much lamented Stillwater Bridge at Old Town was Maine's last double-barrel covered bridge and its last Town lattice truss when removed in 1951. Stillwater Avenue carries an immense volume of fast traffic today, and although the site is still recognizable, it is difficult to imagine a covered bridge here. Built originally in 1835, Stillwater Bridge saw much flood damage early on and appears to have been completely rebuilt later. Until 1870, it was a toll bridge, and the house to the left was the toll house. This view dates from July 29, 1924. (Maine DOT files.)

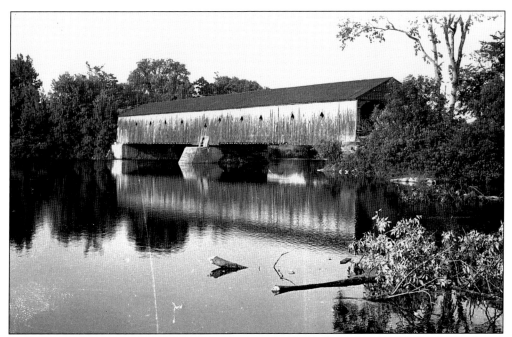
Stillwater Bridge crossed to an island in the river, and it is known as Big Stillwater Bridge in state records. The nearby Little Stillwater Bridge at the other end of the island was probably never covered. (Richard Sanders Allen Collection, NSPCB Archives.)

This photograph by Andrew Adams shows the Town lattice trusses of Stillwater Bridge during demolition in 1951. (Maine DOT files.)

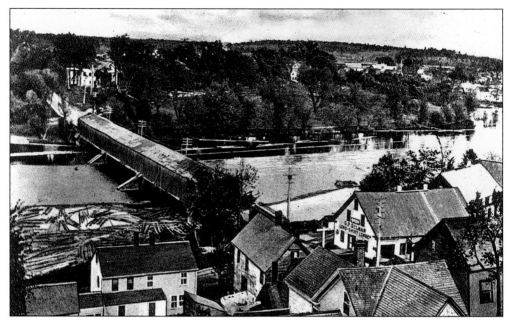

Ferry Hill Bridge at downtown Orono crossed the Stillwater River near its mouth. The Stillwater is really a lengthy side channel of the Penobscot River, circling behind several very large islands. Edward R. Southard built the double-barrel covered bridge in 1831, and it lasted until c. 1912. (Richard Sanders Allen Collection, NSPCB Archives.)

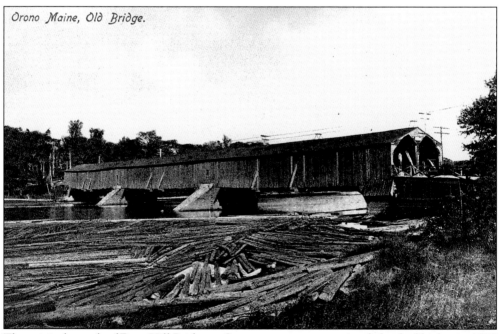

The original portals of Ferry Hill Bridge at Orono were unceremoniously hacked higher in 1895 to permit the passage of a trolley line. (Richard Sanders Allen Collection, NSPCB Archives.)

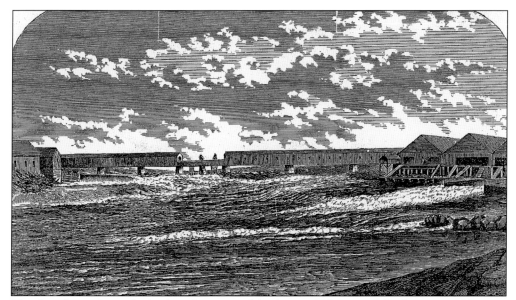

The Penobscot River had a lengthy covered bridge at Old Town Falls, between Old Town and Milford. It dated from 1830, and the builder was probably Isaac Damon. The noncovered section in the middle may have been intended as a firebreak. After washing out in an 1846 flood, it was replaced by a new crossing downstream. Later, there was a covered railroad bridge near this site. (Richard Sanders Allen Collection, NSPCB Archives.)

Downtown Old Town grew up around the 1847 covered bridges built to replace the lost structure at Old Town Falls. There were two bridges, using Orson Island to cross the Stillwater River and its branches northwest of Old Town. (Richard Sanders Allen Collection, NSPCB Archives.)

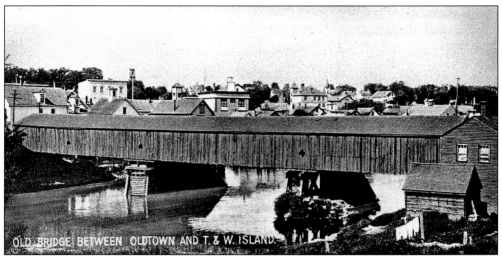

We have little information on the covered bridges over the Penobscot River between Old Town and Milford, but they appear to have been Town lattice trusses. (Richard Sanders Allen Collection, NSPCB Archives.)

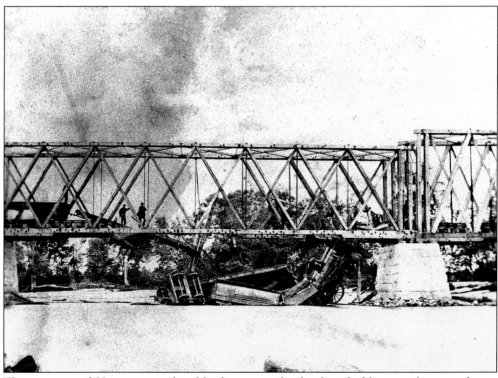

This noncovered Howe truss railroad bridge is not clearly identified but may be part of a set of crossings using Orson Island to cross the Stillwater River and its branches northwest of Old Town. If so, it is of special interest because famed builder Charles F. Powers of Clarendon, Vermont, may have worked on it c. 1869. The locomotive is in the river because of a train wreck, not because the bridge was weak! (From Harold F. Eastman, Richard Sanders Allen Collection, NSPCB Archives.)

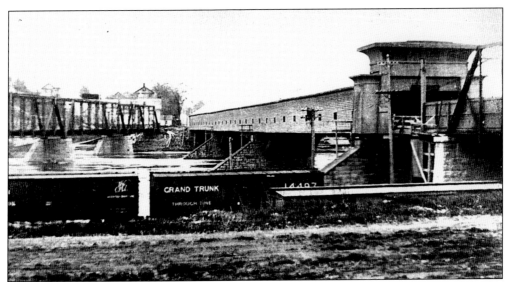

Bangor Toll Bridge, across the Penobscot to Brewer, was one of the best-known covered bridge sites in 19th-century Maine. The first bridge was a Town lattice truss built by Isaac Damon and a Mr. Godfrey in 1831–1832, but it was destroyed by the great ice jam of 1846. This version of the Bangor Toll Bridge went up in 1847 on the Howe patent plan and was wide enough for two lanes of traffic with no center dividing truss. It was 792 feet long and featured an odd Egyptian revival portal on the Bangor end. (Richard Sanders Allen Collection, NSPCB Archives.)

The Brewer end of Bangor Toll Bridge was in a simpler style. To the right is a covered railroad bridge that was built in 1873 and lasted a little over 25 years. The photograph was taken in the 1890s by Charles E. Lunt, toll taker. (Richard Sanders Allen Collection, NSPCB Archives.)

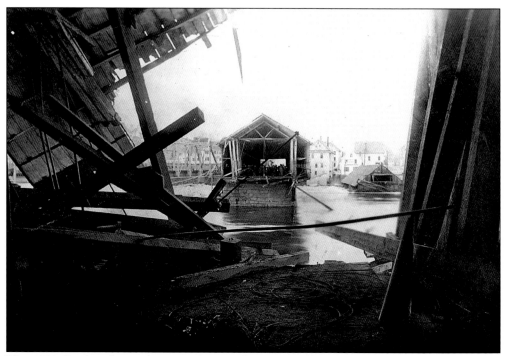

The 1902 flood took out the central span of Bangor Toll Bridge. Some histories report that the entire covered bridge was then removed, but in fact a new steel span replaced just the missing part. In 1912, the rest was rebuilt as an all-steel bridge. (Richard Sanders Allen Collection, NSPCB Archives.)

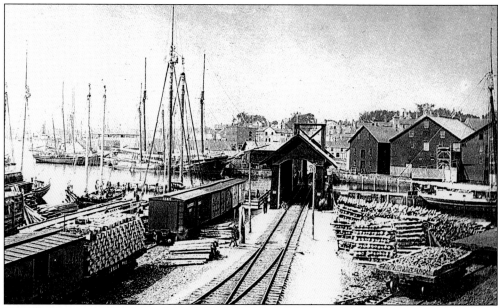

The Bangor waterfront briefly had a covered railroad bridge over the mouth of the Kenduskeag Stream. It had two covered spans separated by an open draw. (Oscar Lane Collection, NSPCB Archives.)

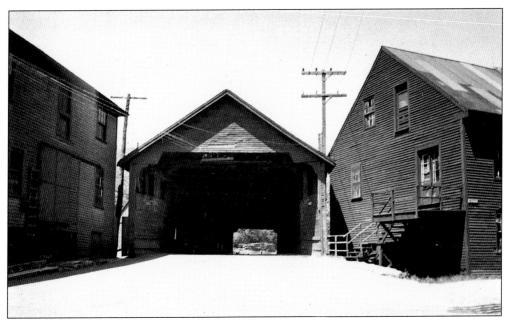

Morse Bridge, built in 1884, crossed the Kenduskeag Stream in an urban setting on Valley Avenue in downtown Bangor. The portals were modified in 1898 to install a trolley line. The bridge was removed in 1961, but the timbers were carefully stored and re-erected over the Kenduskeag in nearby Coe Park in 1965. The story seemed to have a happy ending, but an arsonist destroyed the structure in 1983, and the number of Maine's covered bridges dropped from 10 to 9.

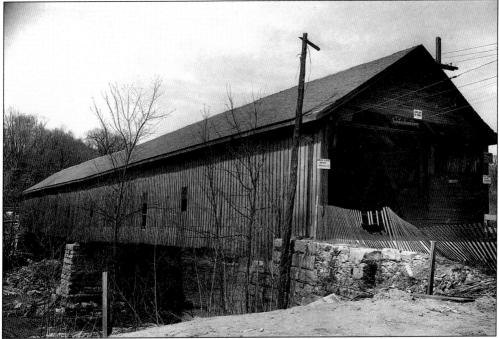

This later view shows Morse Bridge still in service, but some of the mills have been removed. It was a Howe truss. (Author's collection.)

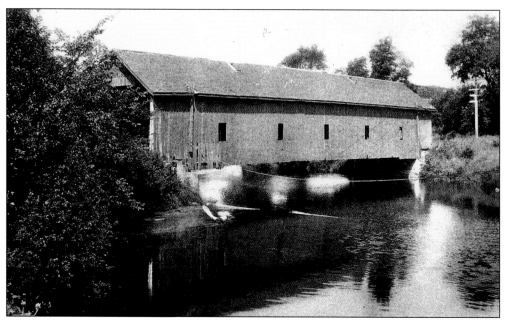

Valley Avenue recrossed the Kenduskeag Stream half a mile upstream on the Maxfield Bridge, which was another Howe truss. It was built in 1872 but was lost in 1944 to a fire thought to be arson. The site is briefly visible from Interstate 95. (Richard Sanders Allen Collection, NSPCB Archives.)

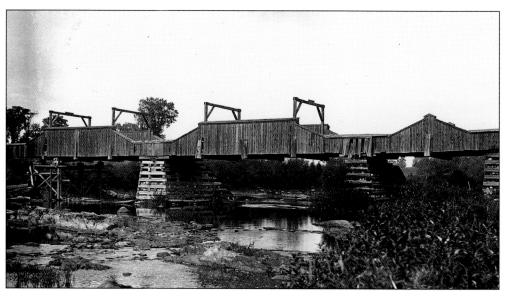

Farther up the Kenduskeag Stream, there were two impressive boxed pony trusses. One was on Griffin Road, and the other (pictured here) was on a stretch of Pushaw Road that was abandoned after the 1936 flood destroyed the bridge. (Maine DOT files.)

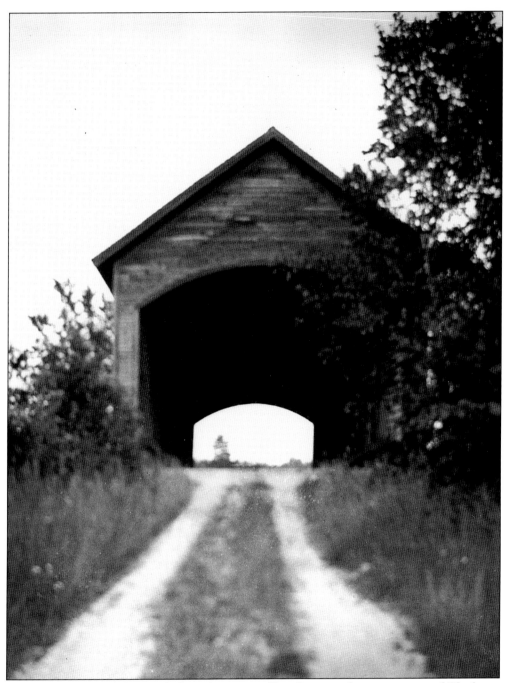

Cahill Bridge crossed the Kenduskeag Stream on Ohio Street in the western part of Glenburn. It collapsed in 1946, and there is no bridge at the site today. For some reason, photographs are very rare. This one was taken on July 30, 1924, at which time there was evidently little traffic. (Maine DOT files.)

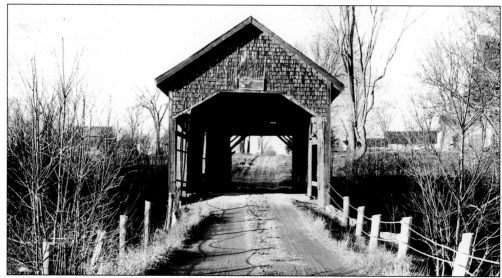

Maine's last all-shingled covered bridge spans the Kenduskeag Stream at Robyville, in the town of Corinth. Built in 1876, it is a Long truss and has the characteristic wedges on the counterbraces for prestressing the truss frame to resist deflection. Since 1983, steel beams have carried the live load. This view by Lucy Loekle Kemp probably dates from the early 1950s. (NSPCB Archives.)

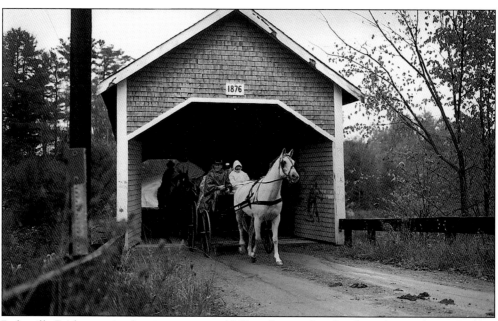

Robyville Bridge received major repairs in 1958 and since then has been kept tidy.

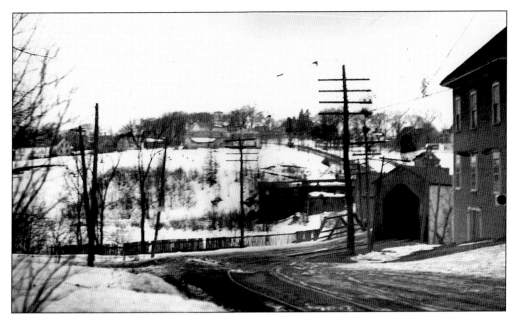

Although several covered bridges were later modified for trolley traffic, this is the only one known to have been built specifically for this purpose. It crossed the Souadabscook Stream at Hampden on the Bangor, Hampden, and Winterport line and lasted from 1897 to 1925. The photograph was taken on March 11, 1924. (Maine DOT files.)

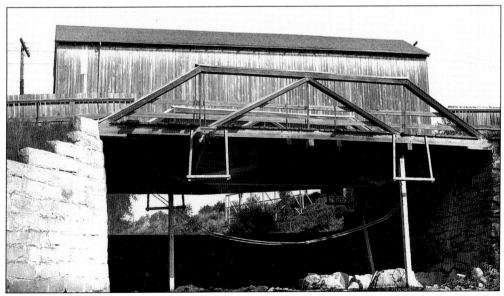

Next to the trolley car bridge at Hampden was an open wooden truss bridge for highway traffic. This photograph was taken in 1922. (Maine DOT files.)

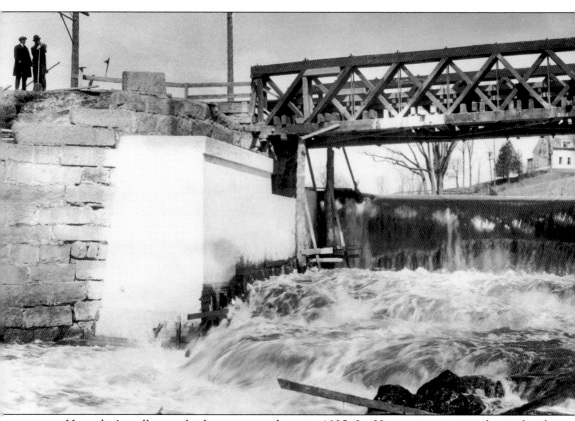

Hampden's trolley car bridge was torn down in 1925. Its Howe trusses were of pony height, although fully housed and roofed. The new concrete bridge served both road and tracks until trolley service was discontinued in 1940. (Maine DOT files.)

Nine
PISCATAQUIS COUNTY

Most of Piscataquis County's covered bridges were of the Long truss type. The very last one was Low's Bridge between Guilford and Sangerville, west of Dover-Foxcroft, which was destroyed in the great flood of 1987. A modern covered bridge replaced it in 1990, which is also a Long truss, but much heavier than the original one.

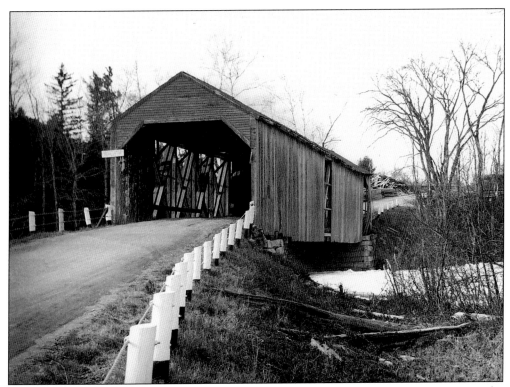

Just east of Abbot Village (or Lower Abbot), a railroad came through in 1874, but it was on the other side of the Piscataquis River. People in Upper Abbot opposed a bridge that would benefit their competitors in the other village. Mark Pease built this Long truss covered bridge in 1878. It was replaced in 1940, but the original stonework, built by Jotham Works, still supports the present bridge. (Maine DOT files.)

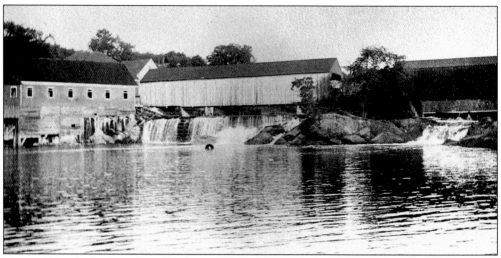

Upper Abbot had twin covered bridges crossing the Piscataquis River by means of a tiny island. The one to the left burned down in April 1917, and the one to the right was replaced in 1929. (Richard Sanders Allen Collection, NSPCB Archives.)

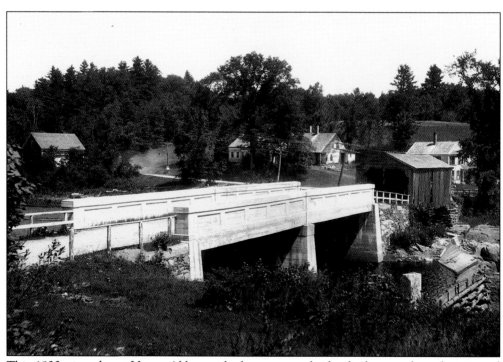

This 1923 view shows Upper Abbot with the concrete bridge built to replace the covered bridge lost to fire in 1917, while the second "twin bridge" still stands in the background. (Maine DOT files.)

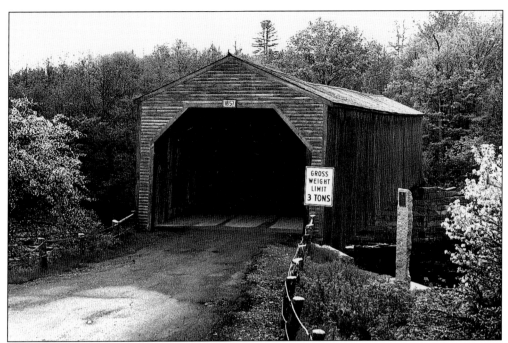

Low's Bridge, over the Piscataquis on the Guilford-Sangerville town line, was built by Leonard Knowlton in 1857 to replace a previous bridge lost to high water. When it was destroyed by the flood of April 1, 1987, it was still in nearly original condition. This photograph was taken in 1983, as was the next.

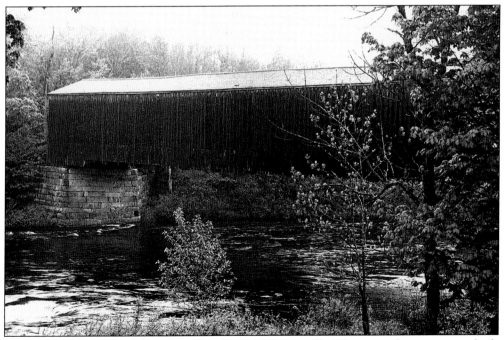

Morning fog lifts at the old Low's Bridge, Guilford-Sangerville. The stone abutments were built by Isaac Wharff and still support the modern covered bridge built in 1990.

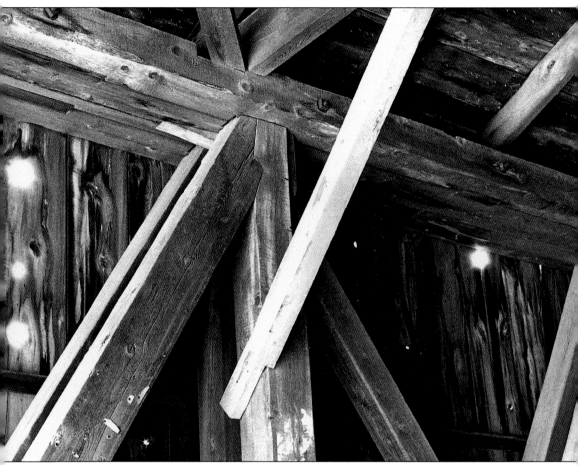
Low's Bridge was a classic Long truss. You can see the wedges protruding from between the posts, which can be used to prestress the counterbraces to help the bridge resist deflection under load. Upstream from Low's Bridge, there were once covered bridges at Sangerville Station and at downtown Guilford.

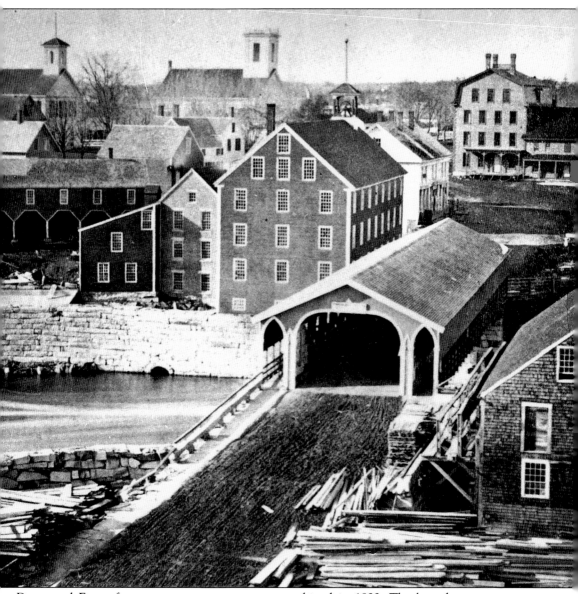

Dover and Foxcroft, once separate towns, were combined in 1922. The boundary was not the Piscataquis River, but rather a straight line that ignored the river's meanderings. Foxcroft Bridge, in what is today downtown Dover-Foxcroft, was near the town line, but entirely in Foxcroft. This photograph was taken from Dover. It was a Howe truss built in 1854–1855, and it survived the terrible 1857 flood because the nearby power dam gave way just as the ice cakes were building up high. The torrent took out Dover Bridge downstream instead. Foxcroft Bridge gave way to a concrete arch in 1911. The second building to the left on the far side of the bridge, and the stone retaining wall to the left, are all that remain of the scene today. (Richard Sanders Allen Collection, NSPCB Archives.)

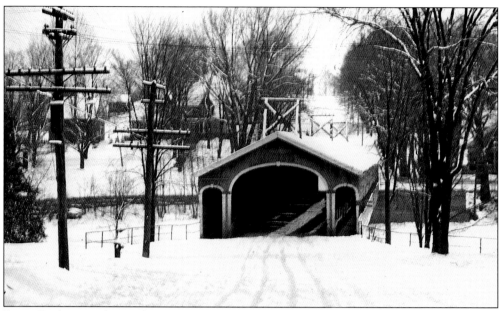

Dover Bridge was also in what is now downtown Dover-Foxcroft but was farther east, just over the former town line in Dover. It was similar to Foxcroft Bridge in appearance, and photographs of the two are often confused. Although both bridges had sidewalks on each side, those of Dover Bridge had a plainer style. Also, Dover Bridge was a Long truss, and it had two spans, although these details are not visible in this 1929 photograph. Built in 1857 after its predecessor was lost to flood, it lasted until 1930. (Maine DOT files.)

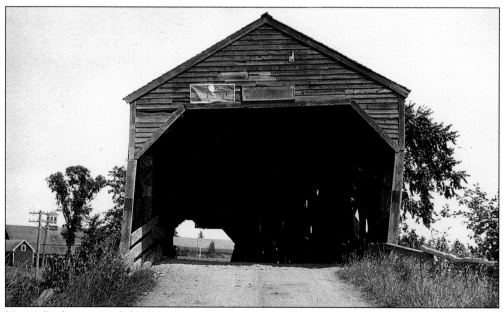

Union Bridge spanned the Piscataquis River in agricultural country between South Sebec and Atkinson, until removal in 1931. This is a 1924 view. (Maine DOT files.)

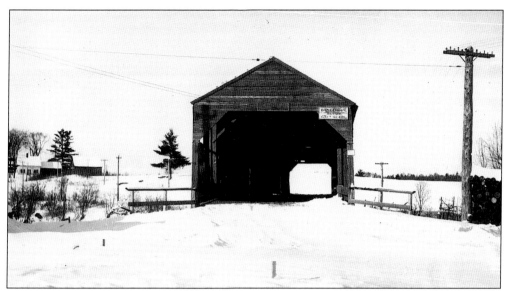

Milo once had three covered bridges. This one, known as the Toll Bridge, crossed the Piscataquis River two miles southeast of the village. It was built in 1855, following plans drawn up by Nathaniel Chamberlain, and was torn down in 1926. This photograph is from its last days in December 1925. (Maine DOT files.)

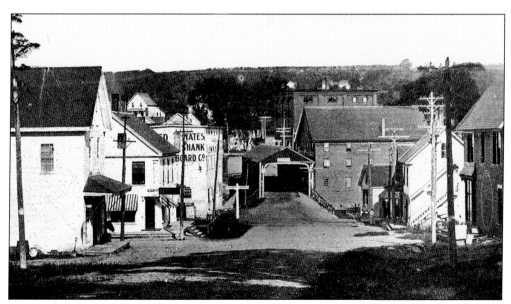

Brownville's covered bridge over the Pleasant River was built in 1857 to replace a previous covered bridge lost to a flood. It burned down in August 1915, along with much of the downtown. (Richard Sanders Allen Collection, NSPCB Archives.)

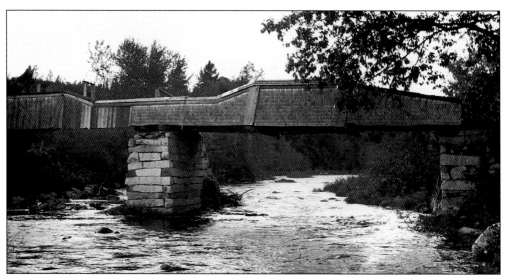
Pease Bridge, over the Kingsbury Stream in a quiet section of Parkman, was one of several boxed pony trusses in Piscataquis County. (Maine DOT files.)

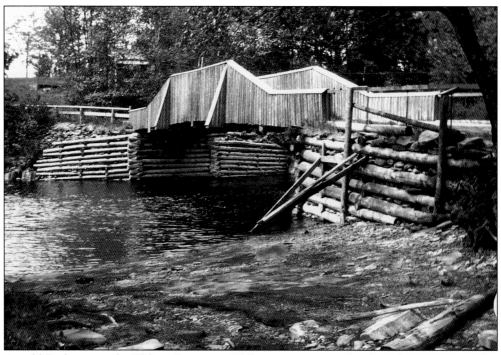
Arnold Bridge, over the Wilson Stream in Willimantic, was another boxed pony truss, and it sat on impressive wood crib abutments. (Maine DOT files.)

Ten
SOMERSET COUNTY

Somerset County probably had more variety in covered bridge truss types than any other Maine county. Here were bridges on the Town lattice, Long, Haupt, and Pratt plans, plus several others whose type is unknown. Covered bridges served far-flung settlements such as Jackman and the former location of Flagstaff. There are none left in the county today, but the famed wire suspension bridge at New Portland still carries traffic over the Carrabassett River.

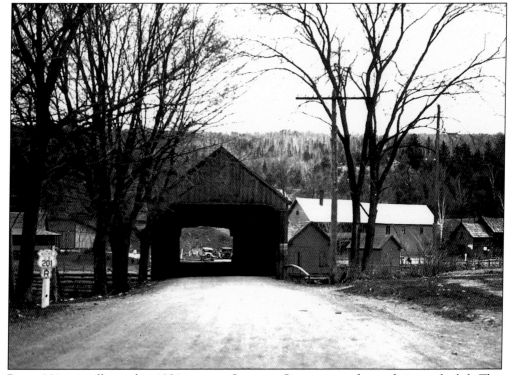

Route 201 was still gravel in 1931 in upper Somerset County; note the road sign to the left. This view is from West Forks to the Forks, where the road crossed the Kennebec River on a covered bridge built in 1877–1878 to replace a narrow earlier covered bridge. (Maine DOT files.)

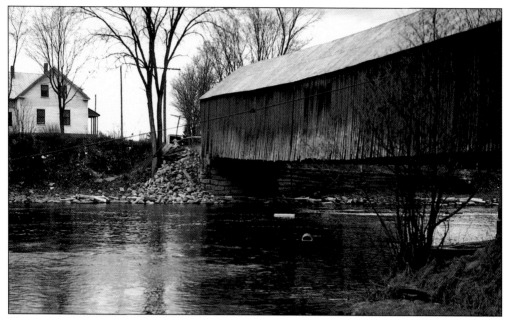

The covered bridge over the Kennebec between the Forks and West Forks was a rare Haupt truss, which saw sporadic use in Maine, although its history in the state is not well understood. However, this bridge's siding went all the way to the eaves, so it is impossible to see any details of the interesting truss. (Maine DOT files.)

Approaching the covered bridge between the Forks and West Forks in 1931, it is hard to believe that Route 201 ever looked so rustic. The bridge was removed in 1932. (Maine DOT files.)

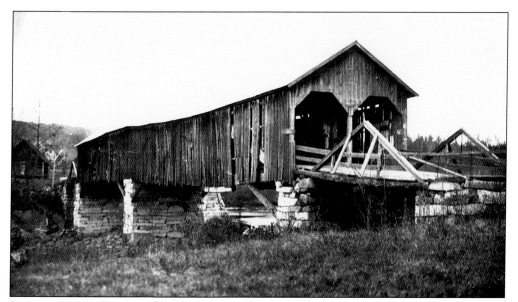

East New Portland's covered bridge over the Carrabassett River was built by Abram Richardson in 1863, after high winds had destroyed a previous bridge. Some of the timber was reused, and the truss appears to be some kind of elongated multiple kingpost design, although it is difficult to be certain. Note the little open kingpost trusses at each end. (Maine DOT files.)

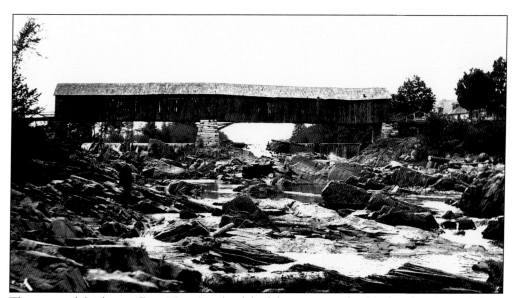

The covered bridge at East New Portland had become ramshackle by the time of these photographs in 1921–1922, and it was replaced in 1923 by an attractive concrete arch bridge that is still in service. (Maine DOT files.)

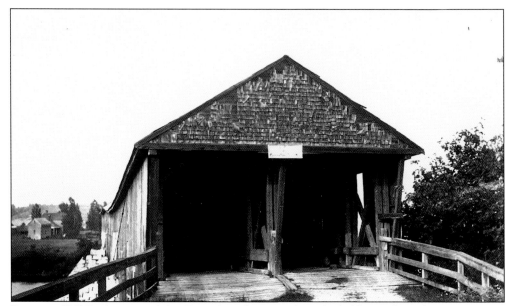

Patterson Toll Bridge crossed the Kennebec about a mile and a half east of North Anson. It was once one of Maine's most famous covered bridges but is now nearly forgotten, and there has been no crossing here since the covered bridge burned down in 1926. It was officially condemned as unsafe in 1921, the year that famed bridge engineer and historian Llewellyn N. Edwards took this photograph. (Maine DOT files.)

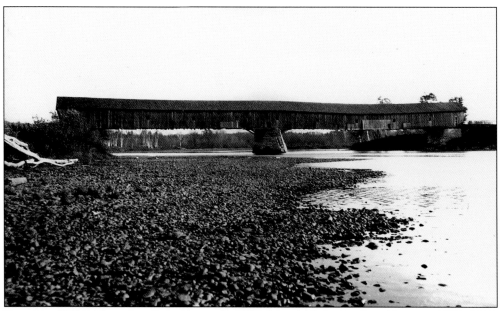

Patterson Toll Bridge was a Long truss whose framer was Ephraim Spaulding, in 1839–1840. Toll was collected until c. 1916. (Maine DOT files.)

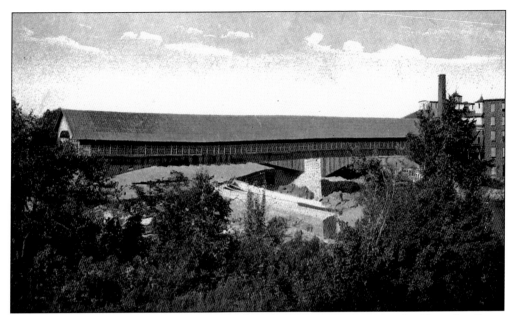

Downtown Madison had an odd covered bridge of unknown type crossing the Kennebec River to Anson. It started out as a boxed pony truss but was fully roofed over in the 1870s, keeping the old trusswork. It was lost to the 1901 flood. Just upstream on the Kennebec was a Town lattice truss covered railroad bridge, and there was a similar structure over the Carrabassett at North Anson. (Richard Sanders Allen Collection, NSPCB Archives.)

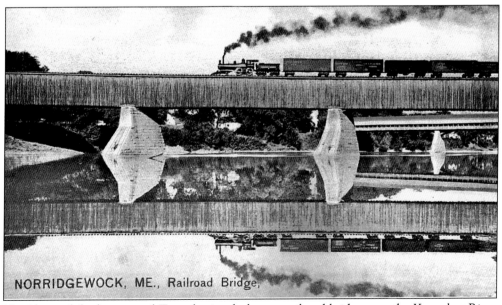

Norridgewock had a covered Town lattice deck truss railroad bridge over the Kennebec River from the early 1870s until c. 1921. The nearby covered highway bridge is in the background to the right. (Oscar Lane Collection, NSPCB Archives.)

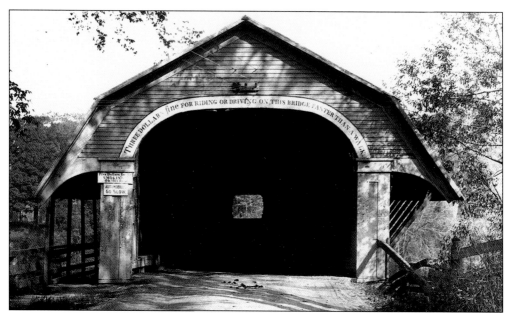

Norridgewock's lovely covered highway bridge over the Kennebec was built in 1870 by a Mr. Pierce. It was one of only two known New England covered bridges with a gambrel roof. This feature seems to have been intended to cover a sidewalk on each side, but only the upstream one was built. Note the sign advertising a fine for speeding; the regular tap of a horse's faster gaits set up a vibration that could cause serious damage to bridge trusses. (Maine DOT files.)

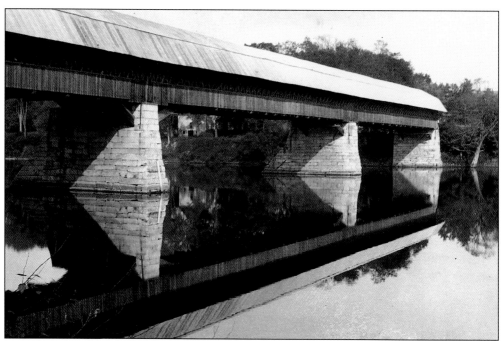

The views on this page of Norridgewock's covered bridge date from October 8, 1923. The bridge was removed in December 1929 after completion of its concrete replacement. (Maine DOT files.)

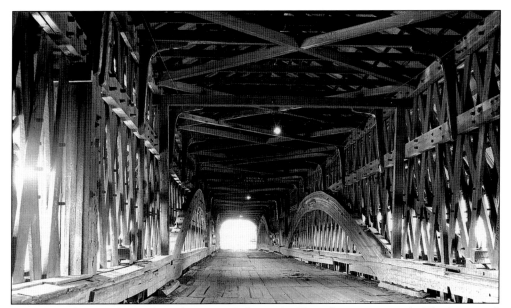
A view inside Norridgewock Bridge in 1927 shows the Town lattice trusswork. The laminated arches and the ship's-knee sway braces were probably later modifications. (Maine DOT files.)

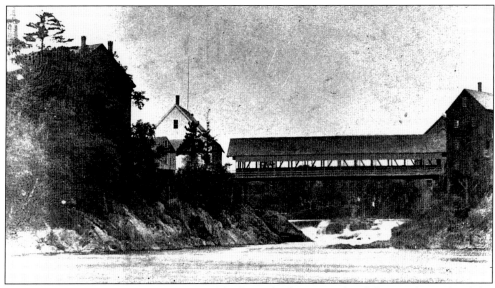
Downtown Skowhegan had two covered highway bridges over the different channels of the Kennebec River. An early bridge of unknown type over the North Channel washed out in 1855, after which contractor Enoch L. Childs built this covered bridge. (Richard Sanders Allen Collection, NSPCB Archives.)

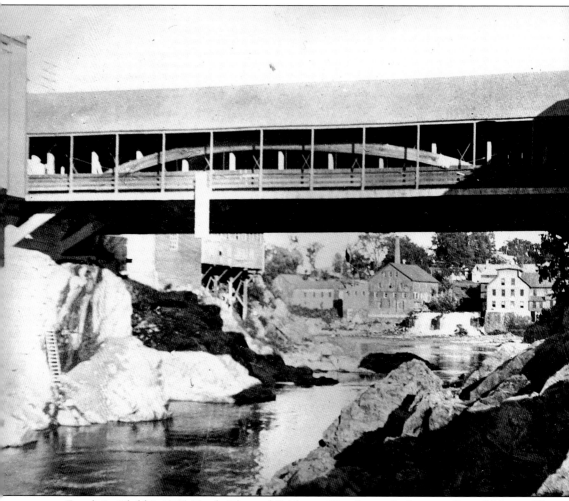

Enoch L. Childs's 1855 North Channel Bridge at Skowhegan had a complicated history. The man himself is interesting, for he came from a famous bridge-building family in Henniker, New Hampshire, and his brother Horace patented his own bridge truss in 1846. Enoch did railroad work for a while in Augusta, Maine, and he seems to have been an innovator. For North Channel Bridge he used the Pratt truss, patented in 1844, which was complicated to frame and did not become popular until it was later modified for use as an all-steel truss. This bridge seems to have had trouble, and the view on page 125 shows it with some temporary multiple kingpost bracing added. This bracing was later removed, and laminated arches were substituted, as we see here. The covered bridge lasted until 1903. (Richard Sanders Allen Collection, NSPCB Archives.)

The South Channel Bridge at Skowhegan was a more conventional Town lattice truss, built in 1869 and removed in 1904. (Richard Sanders Allen Collection, NSPCB Archives.)

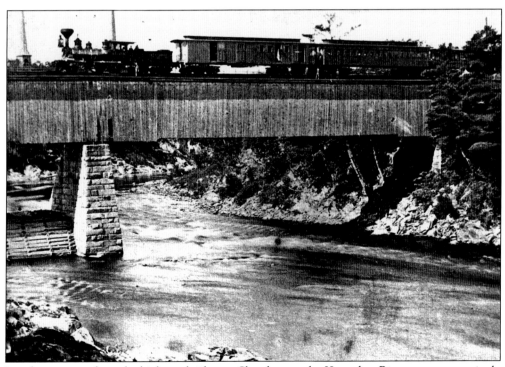

Just downstream from the highway bridges at Skowhegan, the Kennebec River returns to a single channel and was spanned by this high deck truss covered railroad bridge, built in 1857 and replaced by an iron bridge in 1880. (Richard Sanders Allen Collection, NSPCB Archives.)

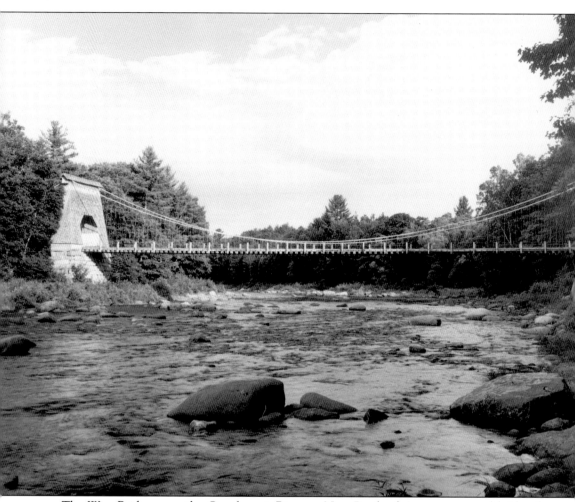

The Wire Bridge, over the Carrabassett River at New Portland, is not a covered bridge, but the wooden towers are shingled over to protect them from decay. Maine once had other wire suspension bridges at Gilead and at Strong, plus a chain bridge at Kingfield. The structure at New Portland is the last survivor of the state's 19th-century suspension bridges.